Emily Post's

wedding planner
for
moms

Also from the Emily Post Institute

How Do You Work This Life Thing!

"Excuse Me, But I Was Next . . ."

Emily Post's Wedding Planner, Fourth Edition

Emily Post's Etiquette, 17th Edition

Emily Post's Wedding Etiquette, Fifth Edition

Emily Post's Entertaining

Emily Post's The Etiquette Advantage in Business, Second Edition

Essential Manners for Couples

Essential Manners for Men

Emily Post's The Gift of Good Manners

Emily Post's The Guide to Good Manners for Kids

Emily Post's Favorite Party & Dining Tips

Emily Post's

wedding planner *for* moms

Peggy Post

wm

WILLIAM MORROW
An Imprint of HarperCollins*Publishers*

Produced by Smallwood & Stewart, New York City
Designed by Alexis Siroc

Library of Congress Cataloging-in-Publication Data
Post, Peggy
Emily Post's wedding planner for moms / Peggy Post.—1st ed.
p. cm.
ISBN: 978-0-06-122800-1
ISBN-10: 0-06-122800-1
1. Wedding etiquette. 2. Weddings—Planning. I. Post, Emily, 1873–1960.
II. Title. III. Title: Wedding planner for moms.

BJ2051.P625 2007
395.2'2–dc22
2006049759

❖
19 20 SCP 10 9

I dedicate this book to my two moms
—Elizabeth Grayson and Elizabeth Post—
both of whom have been inspirations to me at my own
wedding and throughout the years.

contents

acknowledgments

This book wouldn't have been possible without the input of countless moms — all of them concerned about how to help their sons and daughters plan their weddings. There are two mothers in particular whom I wish to thank: Meg Duckworth (a mother of the bride) and Ruth Martin (a mother of the groom). Both of these moms shared with me the many questions they encountered and the terrific efficiencies they discovered while assisting their offspring with their weddings.

Putting this book together was a great exercise in empathizing with the potential end users — namely, all the mothers, stepmothers, and grandmothers of brides and grooms. My sincere gratitude goes to Royce Flippin for his diligence and creativity in helping me find the unique tone for explaining the various roles of guide and anchor that moms take on when planning their sons' and daughters' weddings.

My thank-you also goes to Toni Sciarra and Mary Ellen O'Neill and their editorial and design teams at HarperCollins for their steady help and excellent ideas. Many thanks, too, to Cindy Post Senning, Katherine Cowles, and Peter Post for their tireless support.

There are a number of wedding professionals who also pitched in to make this mom's planner all the more beautiful and meaningful. Alexis Siroc and Smallwood & Stewart's designing talents truly captured the spirit of this book. And I greatly appreciate the wise insights, all based on real-life wedding experience, from the following professionals: Mark Kingsdorf, Lee Minarczik, Elene (Lindy) Bengston, Linny Correa, Georgette Diaz, and Gustavo Mottola.

before you get started

Great news: your daughter or son is getting married! There's nothing more wonderful than knowing your child has found that special someone to share a lifetime with. And naturally, you want their wedding to be equally special — a coming together of family and friends in a joyous, seamless celebration of two people entering into a sacred union.

Before you do anything else, take a moment to savor the thrill of this great news. Finished? Good! Now roll up your sleeves — because whether you're deeply involved in every aspect of planning the wedding or whether the bride and groom prefer to rely on you as a sounding board while making the major decisions themselves, it's likely that you're still going to find yourself juggling the roles of adviser, therapist, communications hub, and trouble-shooter. You'll need to be able to...

- Keep the planning process on track without nagging
- Offer guidance without being pushy, and
- Be a rock of supportive encouragement throughout — even if you disagree with the bride and groom on a particular decision

All this, of course, is in addition to any specific parental responsibilities that you take on, such as throwing an engagement party, spreading the word about gift registries, contributing to the guest list, bonding with your daughter's or son's new in-laws, arranging the rehearsal dinner, negotiating sticky family situations, and welcoming guests at the big event itself.

Finally, there's the issue of who's going to pay for it all. While the parents of the bride are no longer automatically expected to foot the bill for the ceremony and reception, deciding how to split the expenses can be a delicate matter, requiring the utmost tact and empathy.

Having spoken at wedding-planning seminars across the country and answered thousands of wedding questions in my monthly column in *Good Housekeeping* magazine as well as in my articles on the WeddingChannel.com Web site and in *InStyleWeddings* magazine, I've encountered virtually every conceivable wedding dilemma. Of course, each wedding has its own unique issues— but I'm confident that this wedding planner will help you, as the mother of the bride or groom, ensure that the planning process is not only manageable but also enjoyable. When I say "mother," by the way, I'm referring to *all* mothers of brides and grooms. This planner is written for mothers, stepmothers, and grandmothers, as well as any other special adviser to the engaged couple. While the terms "mother" and "mom" are used throughout the book, they can really be applied to any of those close mentors helping with the wedding plans.

Speaking of wedding plans, here are a few general principles to help guide you through the months ahead.

1. **Follow the lead of the bride and groom.** No matter how many good ideas you're brimming with (or how much you're contributing financially), this wedding day belongs to the engaged couple. Your role can be summed up in a simple phrase: "What can I do to help?" Talk early and often about what duties the couple wants to take on, what their priorities and budget are, and where they might like you to pitch in. When you offer suggestions, do so with a light touch, and give way gracefully if your suggestion is overruled.

2. **The mother of the groom should defer to the mother of the bride.** Circumstances vary, of course, but in general, the bride's parents lead the way for all of the parents and other relatives. When it's your son who is getting married, even if you participate in some of the details of the planning process, bear in mind that (with the exception of the rehearsal dinner) the parents of the bride are almost always the official hosts of the ceremony and reception, as well as the major events leading up to the big day. Take your cues from the bride's mother. Check in with her before deciding on your mother-of-the groom outfit for the wedding day. If you want to throw a party, send out announcements, or contribute to the wedding in some way, *always discuss your plans with the parents of the bride first*—then adhere to their wishes.

3. **Keep backup copies of all key information.** Even if the couple is doing a superb job of planning, you'll stand ready to be a hero whenever a glitch occurs if you've maintained a backup record of vendors' names, phone numbers, and street and e-mail addresses; guests' addresses and full names; information on hotel accommodations; and wedding gifts received (when feasible). In addition, you'll be in a position to give a gentle reminder when necessary—or even offer to take over a given task, if the wedding preparations should fall behind schedule.

4. **Communicate on a regular basis.** Mothers who have been involved in the successful planning of a wedding invariably report that they made a point of staying in regular touch with the bride and groom, communicating at least once a week by phone or e-mail, and more often as the wedding date drew near. Regular chats— whether conducted online or verbally—allow you to address problems as soon as they arise and also give you an opportunity to provide ongoing emotional support to the bride and groom.

Emily Post's Wedding Planner for Moms is designed to help you do all of the above and more. It will walk you through every step of the planning process that you may be called to give advice on, while also offering tips on the items that you, as the mother of the bride or groom, need to focus on personally, from drawing up your invitation list to selecting a dress for the big day to arranging a post-wedding brunch. Here are some of the elements you'll encounter in the pages that follow:

❖ **"Planning at a Glance" checklists:** This feature, at the start of each section, is a concise checklist of tasks covered in that section. Each checklist includes a section titled "Just for Moms," containing the items that directly concern you, as the mother of the bride or groom, and another called "For the Couple," listing key steps in the overall planning. In addition, a master timeline (page 3) in Chapter One summarizes the entire planning process, from engagement announcement to honeymoon.

❖ **Mother's Etiquette Alerts:** These short sections highlight specific responsibilities or potential pitfalls that mothers need to be aware of.

❖ **Planning Worksheets:** These pages, found in the Resources section (page 118), provide a ready-made way to keep track of budget and expenses, guest lists, hotel accommodations, gifts, and more. Each worksheet is

designed to be easily copied for repeated home use. (You may want to make one set of worksheets for yourself and give a duplicate set to the bride and groom.)

- **Adviser to the Bride and Groom:** There's an art to giving advice without being pushy. These sections contain hints on how you can help guide the bride and groom through the planning process — including suggestions on how to handle such tricky issues as dealing with divorced parents, whether to invite children of family members, and more.

- **Stress-Busting Tips:** Even the best-organized planning process can have its tense moments — which is why this book includes special "de-stressing" tips for taking pressure off of the bride and groom (and you!).

- **"Ask Peggy"** sidebars, in which I answer frequently asked questions.

- **Organizer Pocket:** This handy pocket, inside the back cover, will let you store receipts, business cards, sample menus, and memorabilia.

- **Address Book:** The back of the planner contains a handy address book (page 136), where you can fill in the names and contact information for site managers, vendors, members of the wedding party, and other key individuals.

Most important of all, *Emily Post's Wedding Planner for Moms* will show you how to apply the three principles of etiquette — respect, honesty, and consideration — to guide and shape the planning process in a gracious, constructive way. By using tact and common sense, you'll find you can navigate this exciting time with a minimum of frayed nerves, hurt feelings, or overstepped boundaries.

As the mother of the bride or the groom, you have the goal, I know, of helping the happy couple have the wedding of their dreams. I hope that this planner will help make their wedding day just as special as they — and you — have always envisioned it would be.

Peggy Post

Winter, 2007

your daughter/son is engaged!

─🙙 THE ORGANIZED MOTHER 🙚─

Maybe your child lives in another part of the country and has asked you to lead the wedding planning process on the home front. Or perhaps the couple is spear-heading the planning but is looking for your advice and feedback on certain matters. Either way, if you really want to be helpful to the bride and groom, you need to be supportive, empathetic—and *organized*. The best place to start? In the words of one mother of the bride, "Keep copies of *everything*." This applies to your own wedding-related duties in particular. In addition, offer to keep a set of backup records for the bride and groom—including copies of the master guest list, contracts, invoices, and contact information for service providers. This way, the couple will know that an extra copy of their key wedding information is just a phone call or an e-mail away.

Top Tips—From Mom to Mom

In putting this planner together, I solicited advice from a number of mothers who weathered their daughter's or son's wedding with grace and aplomb. They shared the following top tips:

* Work with the bride and groom to create a *master to-do list*, preferably in time sequence. The Master Timeline on page 3 will give you an excellent starting point. In addition, the "Planning at a Glance" checklists throughout this book can help form the basis of your master list.

* Maintain a comprehensive *contact list for all service providers*, containing the names, phone and fax numbers, and street and e-mail addresses of every person or company you and the couple are working with. As vendors are selected, you can store all of this information conveniently in the Address Book on page 136 at the back of this planner.

* Compile a *master wedding guest list* of every guest invited to the wedding. A good idea: Create a computer spreadsheet for ease in recording all RSVPs, counting and sorting guests who are attending, and mailing lists to and from the couple. If you are less than computer savvy, your daughter or son might teach you some basics. Or you can compile the list using the "Wedding Guest List" worksheet on page 119.

* Keep copies of *guest lists for any wedding parties*, including engagement parties, showers, rehearsal dinner, bridesmaid luncheon, post-wedding late-night party or next-morning brunch. (See page 120 for a "Party Guest List" worksheet that can be copied and used for any wedding-related event.)

* Keep careful records of *all shower and wedding gifts*, including a full description of each, who gave it, and whether a thank-you note has been sent. (You can use the Wedding Gift Record on page 121 and the Shower Gift Record on page 122.)

* Set up an easily accessible *master calendar* for entering all wedding-related appointments and events.

* Keep copies of *all contracts and invoices* along with *any pertinent items* — such as fabric swatches, photos of gowns, photos of locations, table measurements — in separate file folders or an accordion file folder with multiple pockets.

* Keep notes of *all wedding-related phone calls* and copies of *all wedding-related letters and e-mail* received and sent. Print out hard copies of key e-mail correspondence and keep them on hand for quick reference.

* *Check off completed "to-do's"* as they're accomplished. You'll feel great as you see the number of check marks grow!

* *Keep the lines of communication open* with the bride and groom by staying in touch on a regular basis.

Mom's Wedding Planner Master Timeline

The following timeline is a summary of virtually everything that needs to get done in the weeks and months leading up to the big day. Each section includes a checklist titled "Just for Moms," containing specific items that you need to be aware of, as well as a "For the Couple" checklist covering the overall wedding planning process. This master timeline will allow you, the couple, and any other interested parties to stay on top of the planning process. (For convenience, you may want to copy this outline and share it with the bride and groom.)

Of course, this timeline is just an estimate. Some couples get engaged and married within just a few months—compressing the planning process into a much shorter time frame. Others take up to two years—or more—to plan their celebration. Each couple's to-do list is unique to their own situation. What you'll find below are the most typical tasks involved in planning a wedding. Note, too, that many couples will ask their mothers to help with various items in the "For Couples" sections. Planning a wedding is the couple's prerogative—but they will be more than glad to know that you stand ready to help!

First Steps: 12 to 24 Months in Advance

Just for Moms

- ○ Send an engagement announcement to the newspapers if desired (this is traditionally done by the parents of the bride).

- ○ Arrange a meeting or, at the very least, a phone call between the two sets of parents; in the past this first contact was traditionally initiated by the parents of the groom, but these days it doesn't matter who calls whom first.

- ○ Discuss the general wedding plans with the couple, including size and division of guest list, budget, and division of expenses.

- ○ Begin thinking about whom you'll want to include in your portion of the guest list. *cousins, etc.*

For the Couple

Friday? early Nov

- ○ Decide on the date and time of the wedding, and send out "save the date" notices if desired.

→ Shared Budget

→ Shared Calendar *Master*

- ○ Choose the style of the wedding—formal or informal, traditional, theme, destination, civil or religious.
- ○ Determine a budget and discuss the division of expenses with your parents.
- ○ Decide on the size of the guest list and the number of attendants. *5 each*
- ○ Select an officiant or clergy member to perform the ceremony. *TBD mark*
- ○ Choose locations for the ceremony and reception. *(same)*
- ○ Investigate legal requirements for obtaining a marriage license.
- ○ Select your attendants, both female and male.
- ○ Decide if you want to use a professional wedding consultant; if so, interview and hire the consultant. *N|A*
- ○ Interview and book wedding professionals, such as the caterer, florist, photographer, videographer, and musicians.
- ○ Research honeymoon options and destinations.

Next Steps: 9 to 12 Months in Advance

Just for Moms

- ○ Host engagement party—if you have one (the first engagement party is traditionally hosted by the parents of the bride, but the parents of the groom may host a subsequent party).
- ○ Give your portion of the guest list to the bride and groom.
- ○ With the couple, work on developing the master guest list—especially if you are hosting the wedding and/or are going to be receiving the RSVPs.
- ○ Use word of mouth to begin informing guests about where the bride and groom are registered.

For the Couple

- ○ Select the wedding gown and accessories.
- ○ Begin looking for bridesmaids' dresses.
- ○ Finish hiring wedding professionals; sign contracts for services.

- Work with all parents in developing a master guest list, including names, addresses, phone numbers, and e-mail addresses of all invited guests.

- Make honeymoon reservations.

- Open gift registries and start selecting items for the registries.

- If desired, create a wedding Web site.

- Create a gift record so that you can record gifts as received.

On the Horizon: 6 to 9 Months in Advance

Just for Moms

- Finalize your portion of the guest list and confirm with the couple.

- Choose and coordinate wedding outfits; the mother of the bride usually takes the lead on making the selection, then promptly informs the mother of the groom of her choice.

- Offer ideas and assistance to the groom's parents in selecting a place for the rehearsal dinner, as necessary — for instance, if they are hosting and the dinner is in your hometown.

- Discuss with the couple any post-wedding parties you're thinking of hosting (post-wedding day brunches, belated receptions, etc.), then begin selecting dates and venues.

- If using a makeup artist, meet with him or her six months in advance to reserve availability for the wedding day and discuss your skin-care regimen.

For the Couple

- Finalize master guest list; decide whether to include children and guests of single friends; give a copy of the list to the mother of the bride and/or groom, if she is coordinating RSVPs.

- Order bridesmaids' dresses and accessories.

- Select groom's, groomsmen's, and ushers' wedding attire; schedule rentals as necessary.

- Order invitations (including envelopes), announcements, personal stationery, and other printed accessories and invitation enclosures.

- Schedule religious or personal counseling sessions, as desired or required.
- Plan/reserve accommodations and activities for out-of-town guests and attendants.
- Discuss prenuptial agreements; draw up with lawyers if needed.
- If an out-of-town officiant will be performing the ceremony, check with local clergy and/or officials regarding any special regulations or requirements in your area.
- Choose reception menu and type of food and beverage service.
- If the bride is using a makeup artist, she should meet with him or her six months in advance to reserve availability for the wedding day and discuss her skin-care regimen.

Getting Close: 3 to 6 Months in Advance

Just for Moms

- Review with the couple the parents' and other family members' roles in the ceremony.
- Begin developing a strategy for dealing with potentially tricky family issues (divorced parents, special needs of elderly relatives and young children, etc.).
- Finalize plans for any pre- or post-wedding parties you'll be hosting or helping with.

For the Couple

- Apply for or renew passport, if needed for honeymoon.
- Make all remaining decisions about the ceremony, including personal elements such as special vows or readings, participation of children from previous marriages, and so on.
- Meet with officiant to discuss plans for the ceremony and rehearsal.
- Address wedding invitations and announcements; buy and affix postage stamps.
- Finalize plans for post-wedding parties.
- Choose gifts for attendants and for each other.
- Select/order wedding rings; have rings engraved.

○ Set dates for blood test and marriage license.

○ Explore babysitting options for guests, if needed.

Almost There: 1 to 3 Months in Advance

Just for Moms

○ Host/attend wedding showers.

○ Review text of newspaper wedding announcements with couple.

○ Check with the couple regarding any other pre-wedding parties you're expected to attend.

○ Double-check your wedding-day outfit and other wedding-festivities clothes; take care of any final alterations, and check on your shoes and accessories.

○ Make any beauty appointments for the wedding day.

○ If previously arranged with your daughter/son for you to do so, visit the reception site with the site manager (and wedding consultant, if applicable) to check on details.

For the Couple

○ Attend wedding showers (while these were once held only for the bride, an increasing number of grooms now attend them as well).

○ Start to notify banks, employers, and other agencies and organizations of name and/or address changes for the bride and groom.

○ Visit the reception site with the site manager (along with mother and/or wedding consultant, if applicable) to check on acoustics, lighting, and circulation; plan the table setup; and plot locations of cocktail tables, dance floor, bars, wedding cake display table, place-card table, gift table (if any), musicians or DJ, and receiving line.

○ Choose linens and place settings.

○ Coordinate reception décor and floral centerpiece arrangements with florist, the reception site manager, and caterer.

○ Have final fitting of bridal gown and accessories.

○ Have wedding portrait taken, if desired.

- ⟳ Assemble and mail wedding invitations.

- ⟳ Mail wedding announcements to newspapers.

- ⟳ Apply for and obtain marriage license.

- ⟳ Reconfirm honeymoon plans; pay final deposits.

- ⟳ Make sure attendants have purchased/rented outfits and that all necessary alterations have been made.

- ⟳ If a flower girl or ring bearer is participating in the ceremony, confirm that their plans and outfits are in order.

- ⟳ Finalize arrangements for transportation to ceremony and reception.

- ⟳ Make hair, nail, and spa appointments as needed.

Counting Down: The Final Weeks

Just for Moms

- ⟳ Reconfirm rehearsal dinner plans with dinner site coordinator; remind all attendees of time and place (this is done by whoever is hosting the dinner — traditionally, the parents of the groom).

- ⟳ Finalize seating plan for the reception with your daughter/son and the other parents (as necessary and desired).

- ⟳ Review with the couple all transportation arrangements for parents and other family members, as well as any special ceremony seating requirements and receiving line arrangements.

- ⟳ Go over with couple your suggestions for must-have photos and video segments.

- ⟳ Attend pre-wedding parties (where appropriate).

- ⟳ Address and stamp (or delegate preparation of) wedding announcements, if any are to be sent.

For the Couple

- ⟳ Finalize seating plan for the reception (as necessary), using parents' input as desired.

- ⟳ Have final consultations with caterer (including head count) and other professionals as needed.

- Attend pre-wedding parties: bridesmaids' luncheon, bachelor/bachelorette party, and so on.

- Review best man's duties with him, including how you'll be getting the rings to him.

- Prepare list of any special ceremony seating for guests to give to ushers.

- Compile a list of must-have photos and video segments and give this to the photographer and videographer.

- Shop and pack for honeymoon.

- Go over final wedding-day arrangements for you and your attendants: where and when to dress and assemble, transportation to ceremony and reception, wedding party photos, and so on.

- Ensure that wedding announcements, if any, will be mailed by someone (perhaps the mother of the bride or groom) after the wedding.

⤳ SHARING THE HAPPY NEWS ↜

Planning at a Glance

Just for Moms

- ✓ Meet your child's fiancé/fiancée, if you haven't already.

- ✓ Share the happy news. Once your daughter/son and you decide it's time to spread the word about the engagement, tell close relatives first, followed by close friends, then other friends and work colleagues.

- Confer with bride and groom on a newspaper announcement of engagement, if desired.

- ✓ Arrange to meet with the parents of your child's fiancé/fiancée, if you haven't met already.

For the Couple

- ✓ Tell your parents about your engagement before sharing the happy news with other relatives or friends. (The exception is if there are children by a previous marriage/marriages; in this case, the children should be the first to know.)

○ *Arrange a meeting of your parents if they haven't met already.*

○ *Confer with the parents of the bride on the text of a published engagement announcement, if desired; then prepare the announcement for the newspaper(s).*

Whom to Tell First?

Whether your daughter or son's engagement was long expected or a bolt from the blue, there are certain guidelines about who is told first, which have to do with the feelings of those being told. If one or both of the engaged couple have children, they absolutely must be told about the engagement before anyone else, since the news will represent a dramatic change in their lives. (This is especially important for young children.) The next people to hear should be you, the parents. Following that, it's important to get the word out quickly to near relatives — siblings, grandparents, close aunts, uncles, and cousins — as well as good friends, so that they hear about the engagement before anyone else does.

Once the couple has shared their news with you, ask them how they prefer to spread the word to other relatives and friends of the family. You should *not* send out printed announcements of the engagement. These will only add unnecessary expense and can easily be confused with save-the-date notices or even invitations. Instead, the news should be spread by word of mouth — either in person, over the telephone, or through a letter or individual e-mail. It's also okay to publish an announcement in the newspaper, if you and the couple wish.

Getting to Know Your Prospective Son- or Daughter-in-Law

If you haven't yet met the person your daughter or son intends to marry, try to arrange a face-to-face meeting as soon as possible. If distance prevents this, introductions can be over the telephone — but follow this up with an in-person visit as soon as possible. If the couple is dragging their feet, a gentle suggestion is perfectly appropriate: "We're so looking forward to meeting John. Shall we try to pin down a weekend when the two of you might come out for a visit, or we could go to you?"

When you meet, don't worry too much about getting into nitty-gritty details about the wedding, or where the couple is planning to live. Right now, the main goal is to spend some quality time together and bask in the excitement of the big news.

<div>

MOTHER'S ETIQUETTE ALERT

think before speaking

Your child may want to tell certain friends and family members about the impending nuptials personally, so be sure to coordinate sharing the news with the couple *before* you begin telling one and all. Also, be careful that in the excitement of the moment you don't mislead those you tell into thinking they're going to be invited to the wedding when this hasn't yet been determined. People will invariably ask for details about the upcoming nuptials. If the person doing the asking is on your "maybe" invitation list—or isn't on the list at all—simply reply that the wedding plans haven't been drawn up yet or prepare your questioner for a noninvitation by saying something like "It looks like it will be a fairly small wedding..." Vagueness is always a far better approach than making a misleading comment and causing hurt feelings. "I hope you'll be able to come to the wedding!" should be reserved strictly for people you're absolutely certain you'll be inviting.

</div>

Parents Meeting Parents

If you haven't yet met the parents of your daughter's or son's fiancé(e), that meeting should be arranged as soon as possible. The actual invitation can be extended in whatever manner is convenient. While a written note is always nice, a phone call or an e-mail is also fine. The point is to introduce yourself to your future in-laws and share your pleasure over the engagement, then go on to explore the possibility of when you can sit down together. Let the spirit of friendship be your guide: If distance prevents you from getting together before the wedding itself, then both sets of parents should make an effort to stay in touch by calling or writing in the months prior to the big event.

Who actually hosts the get-together and the nature of the occasion are matters of preference rather than tradition. This may be a good time to consult the bride- and groom-to-be, since they're likely to know what kind of gathering will put everyone at ease. A relaxed setting such as a casual barbecue or weeknight supper is often preferred for this all-important first meeting. But if one or both sets of parents have a more formal lifestyle, a good option might be a weekend dinner or brunch at a mid-range restaurant.

STRESS-BUSTING TIP

it doesn't matter who takes the first step

When it comes to meeting your child's future in-laws, don't get hung up on "who should call whom first." While tradition holds that the groom's parents should make the first contact, these days it doesn't particularly matter who makes the first move (although the bride's parents may want to wait a few days, to give the parents of the groom a chance to honor custom). The important thing is for the parents to meet, even if over the phone at first, and share in the spirit of excitement over the future union.

Going to Press

A couple may choose to submit an engagement announcement to newspapers for publication. There's no set rule about the timing of the announcement: Generally, these appear at least two to three months before the wedding date, but they've also been known to appear much earlier than that.

Before writing up an announcement, contact the appropriate department of the newspaper you've selected, to see what steps need to be taken. Engagement announcements are typically brief and follow a fairly standard format (some newspapers may provide their own forms). Traditionally, the announcement is made by the parents of the bride-to-be and includes full names with courtesy or professional titles, the city and state or country where the couple and both sets of parents reside, the highest level of education of the couple, and their current jobs.

> Mr. and Mrs. Thomas Madison of Charlottesville, Virginia, announce the engagement of their daughter, Jane Elizabeth Madison, to David Theodore Alexander, son of Dr. and Mrs. Richard Alexander of Los Angeles, California. A June wedding is planned.
>
> Ms. Madison, a graduate of the University of Pennsylvania, is currently studying law at New York University. Mr. Alexander, a graduate of Lehigh University, is a vice president at JPMorgan Chase & Co. They both reside in New York City.

Planning Ahead: Check on Wedding Announcements Now

If the couple plans on putting a wedding announcement and photo in any newspapers, now—when you're already in touch with the papers regarding an engagement announcement—is a good time to find out what their time frames are for wedding announcements. Some papers require that the information be submitted at least several months before the wedding date.

Let's Celebrate
~📿 The Engagement! 📿~

Planning at a Glance

Just for Moms

○ *Decide whether you wish to host an engagement party. (It's totally optional.)*

○ *Determine whether the couple would like to have a party in their honor. (Note: If they are opposed to the idea, this is one of those times to acquiesce graciously.)*

○ *If the party is going to happen, schedule a date—preferably as soon as possible after the news about the engagement is announced.*

○ *Draw up the engagement party guest list, including the groom's parents (even if they can't attend, this is a thoughtful gesture).*

○ *Issue invitations via mail, e-mail, or telephone.*

○ *Arrange to have the bride's father (or someone else close to her) officially announce the engagement during the party.*

For the Couple

If an engagement party is thrown in your honor . . .

○ *Provide party hosts with names and addresses of people you wish to have invited.*

○ *Thank the hosts of the party at the end of the celebration, and again in writing.*

○ *Write thank-you notes for any gifts you receive.*

We've Decided to Throw an Engagement Party!

An engagement party provides a time to gather family and friends to celebrate the upcoming nuptials and to meet and congratulate the couple. But take note: These joyous affairs are purely optional. Do not feel that you *must* throw an engagement party; some parents simply don't have the budget, the time, or the resources to do so. If you do decide to host an engagement celebration, the atmosphere can range from a backyard barbecue to a casual brunch or cocktail party with hors d'oeuvres to a formal dinner party—whatever feels right for you, the bride- and groom-to-be, and your child's future parents-in-law. The goal is to provide a warm, relaxed setting that allows the important people in the couple's life to enjoy each other's company and toast the happy couple.

 ❋ **Who hosts?** The engagement party is traditionally hosted by the bride's parents (though it can be hosted by any family member or friend), with the groom's parents among the invited guests. Check with the engaged couple before making any plans, both to confirm that they want a party in their honor and to be sure you pick a date that works for them. If the families live in different parts of the country or in different countries,

then the bride's and groom's parents may occasionally decide to each host parties in their hometowns. This is perfectly acceptable. The key here, as always, is for the groom's parents to step back and allow the bride's parents to take the lead. Once the bride's parents have announced the date of their engagement party (or decided not to have one), the parents of the groom can then ask the couple if it would be okay with them if the parents hosted a party of their own.

* **When should the party take place?** The engagement party should occur at the earliest convenient time following the announcement, even if the engagement period is a long one. While it's relatively rare for a couple to have more than one engagement celebration, if there is a subsequent party it should be held at least several weeks after the first one, to avoid overloading the bride and groom and their families.

* **Who's invited?** While an engagement party can be as large or as small as you desire, the guest list is typically limited to the couple's relatives and good friends. It's generally inappropriate to invite anyone to an engagement party who will not be on the wedding guest list as well. The reason: People invited to an engagement party will naturally and logically assume that they'll also be invited to the upcoming wedding, so the goal is not to hurt anyone's feelings by misleading them.

STRESS-BUSTING TIP
save that contact info!

Since the people you invite to your engagement party are most likely going to be invited to the wedding as well, save all the guests' addresses, phone numbers, e-mail addresses, and other pertinent information. Enter the information onto the "Wedding Guest List" worksheet (page 119). This will put you well ahead of the game when you begin compiling the master guest list for the wedding.

can the groom's parents host an engagement party?

Q: *My son and his fiancée announced their engagement several weeks ago. We've met the bride's parents, who live nearby, and get along well with them. However, they haven't mentioned a word about throwing an engagement party for the couple. Would it be appropriate for my husband and me to offer to host a party ourselves?*

A: If the bride's parents choose not to throw an engagement party, it's perfectly fine for the groom's parents to do so. However, you first need to be absolutely certain what the bride's parents' intentions are. Ask your son whether there are any plans for an engagement party—or speak directly with the bride's parents and ask them if they'll be hosting one. If they aren't, go ahead and plan yours, being sure to invite the bride's parents. If both you and the bride's parents are planning to host a party, let them select a date first. Then select a date for yours—ideally after their party.

There are exceptions to this guideline. One example would be the case of parents who want to host an engagement party at their home and wish to include some of their neighbors—even though the neighbors know they're not going to be invited to the wedding, for one of a variety of reasons (perhaps the wedding is going be small or is taking place far away). In this type of situation, the guests understand that they won't be receiving wedding invitations but are still delighted to be included in the festivities.

Record the date, time, and location of all engagement parties in your Address Book (page 136).

Invitations and Toasts

Normally, written or printed invitations are sent out two to four weeks in advance. For a small and/or spontaneous gathering, however, phoned or e-mailed invitations are also perfectly fine. The invitation may or may not spell out what the party is for: In the past, engagement parties often were surprise affairs at

which the bride's parents announced the happy news, and this is still sometimes the case today. When the party *is* a surprise, the invitation might be for a cocktail party, with the exciting news to be announced to unknowing guests.

Whether the news of the engagement is a surprise to the guests or is already widely known, the engagement party is still the time when the bride's father traditionally makes the official announcement and leads a toast to the couple. Other guests can then follow with their own toasts, if they wish.

gifts at the engagement party — or not?

Guests are neither required nor expected to bring gifts to an engagement party, but it seems many people are unaware of this guideline. It's possible that some guests will arrive with gifts, while others (most likely the majority) will not. If this happens, the best thing to do is for either you or the couple to quietly and graciously accept a gift presented by a guest, then discreetly put it aside to open later. This way, those who did not bring presents won't feel uncomfortable—as they surely would if any gifts were opened at the party.

You may be asked by invitees about gifts. Although engagement gifts really are optional, your own decision will depend on local tradition. Feel free to ask others who have hosted or attended recent engagement parties in your area whether it's customary for people to bring gifts. If so, you can certainly follow suit if you wish.

If the more widespread practice of "no gifts" is what you and the couple prefer, and you're concerned that your guests may be unclear about this, let them know via word of mouth that a gift is not expected. (Avoid writing "No Gifts Please" on an invitation to an engagement party, since many people won't be planning on bringing one anyway—and the emphasis on gifts could cause confusion in the long run.)

If gifts at engagement parties are your local custom and are given by everyone, the couple can choose to open them at the party and express their appreciation in person. Note, however, that written thank-you notes are required for all gifts, even if the couple has already thanked the givers directly.

THE BIG DECISIONS
WHERE, WHAT, WHEN, AND HOW?

Planning at a Glance

Just for Moms

○ *Encourage the engaged couple to explore their ideas for a "dream wedding."*

○ *Discuss size and division of the guest list.*

○ *Discuss general wedding plans with the couple, including general overall budget and division of expenses.*

○ *Have a heart-to-heart talk with your daughter or son to determine what role you will play: Will you be actively involved, planning almost everything? A somewhat involved, collaborative adviser? Or just an occasional participant?*

For the Couple

○ *Select the date and time of the wedding.*

○ *Decide on the geographical location of the wedding.*

○ *Choose the style of your wedding—formal or informal, traditional, theme, destination, civil or religious.*

○ *Decide on size and division of the guest list.*

○ *Establish a preliminary budget and discuss division of expenses with parents.*

○ *Decide whether to hire a wedding consultant.*

Living the Dream

As I noted in the Introduction, your goal is to help the bride and groom fulfill *their* vision of their wedding day. That means giving them room to make their own decisions. "Don't immediately push for a wedding date or start making suggestions," says one wedding planner. "Give them some space to savor this special time." When you do get into the planning stage, approach your daughter or son as you would a friend. All you have to do is remember one simple question: "Is there anything I can do?"

One of the most helpful things you can do for the engaged couple is to *help them understand what their own desires are*. Financial considerations will be a factor, of course, but once the couple have agreed on the style and locale of their wedding, they can virtually always find a way to tailor expenses to fit their budget.

Before getting into any debates over large-versus-small or formal-versus-informal, encourage the couple to take some time to dream. What would their ideal wedding look like? Suggest that they each compile a list of words that describe their dream wedding, then rank them in order of importance. Here are some possible adjectives to get the ball rolling:

> Intimate, contemporary, simple, grand, spiritual, family-oriented, elegant, secular, Hollywood-like, casual, tropical, luxurious, musical, ethnic, dramatic, traditional, huge

After the bride and groom have each thought about their "dream wedding," encourage them to merge their two lists, then think carefully about what sort of celebration they're both describing: An intimate gathering of close family and friends in the backyard? An evening gala in a ballroom or reception hall, with everyone decked out in formal attire? An exotic destination wedding at a resort or in a foreign country? The qualities they've chosen for their dream wedding should be the most important guide in making their decision. By adapting their dreams to their circumstances, they'll create a wedding that is uniquely their own.

STRESS-BUSTING TIP

throw a brainstorming party

If the couple is having trouble deciding what kind of wedding to have, a low-key brainstorming session is a great way to take the pressure off. Make it into a party: Put out some food and beverages, then encourage the bride and groom and anyone else in attendance to spend an hour or two tossing around concepts. The only rule is that there are no bad ideas. Let imaginations run wild: What about holding the wedding in an historic home—or on a mountaintop or on the beach in Hawaii? The couple can write out every thought, and then pare the list down to those ideas that seem truly workable. Brainstorming is lots of fun—and surprisingly productive.

Setting a Budget Ceiling and Splitting Expenses

Next, you and the couple will need to come up with an approximate baseline figure for the overall wedding budget, including how much the various parties are willing to contribute. The average cost for a wedding in the United States is now about $22,000—but many weddings fall well below or above that number. The figure that you and the couple come up with will help determine the style and size of the wedding.

It used to be that the parents of the bride were expected to bear the entire cost of the wedding. That's no longer true. Between the rising cost of weddings and the fact that more and more couples are getting married later in life, when their careers are more established, only a quarter of all weddings are now paid for exclusively by the bride's parents, while up to seventy percent of weddings are paid for either by the couple or some combination of the bride's and groom's parents.

Whatever division of expenses you settle on, the key to avoiding misunderstandings is to have a clear discussion at the *start* of the planning process regarding how much each party is prepared to contribute:

- Each party can contribute a fixed amount. In this case, says one experienced wedding consultant, "it's important for both sets of parents to let the couple know in advance how much they're willing to contribute. If you're comfortable contributing $10,000—or whatever the amount might be—to the overall cost, inform the couple of this right up front."
- Another approach is for the different parties to offer to pay for certain aspects of the celebration. For example, the parents of the bride might agree to pay for the reception, while the parents of the groom cover the cost of the rehearsal dinner and lodgings for the wedding party, and the couple pays for flowers, music, the officiant's fee, transportation, and other ancillary costs.
- Another scenario is for the bride's and the groom's parents to split the costs; alternatively, each set of parents might pay one-third of the cost, with the couple paying a third as well.
- Finally, it's increasingly common for the bride and groom to pay for the whole wedding themselves.

don't keep mum about money

As parents of the bride, the key to ironing out the financial details of your daughter's wedding is for you and your spouse to communicate openly with the couple at the very start of the process regarding exactly what sort of monetary contribution you're willing and able to make toward the wedding. You, as a mom, can be a tremendous help simply by initiating the budget conversation, if it hasn't come up already. Keep the discussion within your immediate family, however; the idea that the groom's parents might contribute to the cost of the wedding as well is best broached by the groom directly (and privately) with his parents.

Size and Division of the Guest List

In general, guests at the reception account for fifty percent of the cost of any wedding. Deciding up front the approximate size of the guest list will be crucial to planning a preliminary budget. The couple will need to make the final decision on size. If you're contributing a part of the cost, however, it's perfectly appropriate for you to weigh in should you feel the couple's guest list is unrealistically large.

The bride and groom will also have to decide how the guest slots get allotted. Typically the list is divided into three equal parts, with the parents of the bride, the parents of the groom, and the engaged couple each inviting an equal number of guests. Alternatively, the couple may reserve half the list for themselves and divide the other half equally among both sets of parents.

Formal or Not?

There are three basic categories of weddings: formal, semiformal, and informal. The couple will have to decide what style best suits them. There's no clear line dividing one category from the next—but rather a series of choices involving venue, décor, attire, and the size of the guest list. While formal weddings tend to be on the large side—200 or more guests isn't uncommon—this is by no means set in stone. A formal wedding could be quite small, while an informal wedding

could easily have 100 or more guests. With that in mind, here are some general guidelines on degrees of formality:

- **A** *formal wedding* is typically held in a house of worship, a large private home, or a formal garden. The number of bridesmaids and ushers might range from 4 to 10, with the bride's party dressed in long, formal gowns and the groom and his attendants in cutaways or tailcoats. Guests may number 200 or more, and the later the starting time, the fancier their attire: Dresses and suits are the suggested wear for an afternoon wedding, while gowns and possibly tuxedos would be donned for an evening affair. The meal can be a sit-down dinner or served in food stations.

- **A** *semiformal wedding* may be in a house of worship, home, or garden, but other venues can include a club or hotel. The attendants are usually fewer in number—2 to 6 bridesmaids and an equivalent number of groomsmen—with the bridesmaids wearing tea-length (mid-calf) gowns or shorter and the groom and his attendants wearing formal suits or (especially later in the day) tuxedos or dinner jackets with black trousers. Guests may number 75 to 200, with women wearing dresses and the men wearing suits. Dinner is typically a buffet, cocktail buffet, or food stations.

- **An** *informal wedding* can be held virtually anywhere, from a house of worship to city hall to a beachfront. The wedding party is usually limited to just a few bridesmaids and ushers. Bridesmaids might wear tea-length gowns or shorter, with the groom and his attendants wearing suits or sports jackets and trousers. There are typically 75 or fewer guests, with women in street-length dresses and men in sports jackets and slacks. The meal can range from a brunch to an informal buffet dinner to simple hors d'oeuvres and cake.

To Hire a Wedding Consultant or Not?

For busy people, hiring a wedding consultant is often a smart alternative to trying to do it all themselves. A good professional consultant will help the couple decide on a site for the ceremony and reception; help select and oversee suppliers and vendors; coordinate the rehearsal and the wedding ceremony; serve as an organizer, budget hawk, and friend; and supervise all the last-minute details of the big day itself. The following questions will help you and the engaged couple evaluate the various candidates.

Key Things to Know Before Hiring a Wedding Consultant

- ❀ How many weddings has he or she coordinated?

- ❀ Can the consultant provide client references?

- ❀ What services are provided, and what are their individual prices?

- ❀ Will the consultant be on hand to help on the wedding day at the ceremony and reception?

- ❀ What is the estimated total fee?

To evaluate and compare wedding consultants, use the "Comparison Chart" worksheet (page 123). If and when a wedding consultant is selected, record the name and contact information in your Address Book (page 136).

ASK PEGGY

help ~ my daughter wants a low~key wedding!

Q: *I've always envisioned a fairy-tale, formal wedding for my only daughter, but she's talking about having a very informal, backyard barbecue wedding. I'm sure it will be enjoyable, but I can't help wishing for something a little more special—and I'm willing to pay for it. Any suggestions?*

A: Sit down with your daughter and share your thoughts and feelings in an open, nonjudgmental way. Offer some specific ideas of what you had in mind. Even if the wedding remains casual, your daughter and her fiancé may agree to some of your suggestions—for example, holding the ceremony in a different location or wearing a family heirloom bridal gown or embellishing the reception with a fancy, multilayered wedding cake or floral centerpieces. These touches fit in with the most casual weddings, while adding a touch of glamour. Whatever you do, don't dig in your heels or hold the power of the purse strings over the couple. Ultimately, it's their decision.

~~ ESTABLISHING A BUDGET ~~

Planning at a Glance

Just for Moms

○ *Let the couple know how much you're willing to contribute to the wedding.*

✓ *Confirm total budget and division of expenses with the couple.*

○ *Assist where appropriate in drawing up a detailed wedding budget.*

For the Couple

○ *Discuss with each set of parents how much they're willing to contribute to the wedding costs, then come up with a total budget figure.*

○ *Set budget priorities—where to skimp and where to splurge?*

○ *Draw up estimates of how much you're prepared to spend on specific items (caterer, flowers, music, photography, etc.).*

○ *Develop a detailed wedding budget.*

Developing a Detailed Budget

We've discussed the process of determining who will contribute how much to the wedding and establishing a total dollar amount for the wedding budget (see "Setting a Budget Ceiling and Splitting Expenses," page 20). The next step is for the couple to begin setting priorities and then adjust their detailed budget around the categories they feel are most important. If you're helping the couple determine their budget, start by defining as many fixed costs as possible—such as the officiant's fee; postage; or the $50 per-plate fee at the reception site that you and the couple have your hearts set on. Until an actual guest list has been drawn up, use a best-guess estimate for the number of guests that will be attending. The easiest way to keep costs under control is to keep the size of the guest list realistic, in line with the funds available.

Once these mandatory costs are listed, subtract that total from the available funds. What's left is for variable costs, such as flowers, limousines, a videographer,

and music. Each couple will have different fixed and variable costs, based on their personal priorities.

How to Use the Wedding Budget Worksheet

Once the couple's budget priorities are established, fill in the estimated costs for each category using the "Master Wedding Budget" worksheets (page 124). Use the worksheets as a guide when interviewing and pricing vendors. Once a vendor has been selected, write the actual cost of their services on the worksheets, beside the estimated cost.

today's average american wedding

As I've mentioned, the average cost of a wedding in the United States is now around $22,000. You and the couple might also be interested in the following statistics, showing how much of this total budget, on average, is spent on each major expense category:

• Invitations: 1 to 2 percent

• Bridal attire: between 3 and 5 percent

• Food and beverages for the reception (excluding cake): 45 to 50 percent

• Wedding cake: 2 to 3 percent

• Flowers and décor: 8 to 10 percent

• Reception entertainment (DJ or band): 6 to 8 percent

• Photography: 9 to 11 percent

• Videography: 5 to 6 percent

• Transportation: 2 to 3 percent

• Other expenses: 2 to 19 percent

our daughter and her fiancé are pressing us for more money

Q: We told our daughter that we would contribute $20,000 to her wedding. The groom's parents are chipping in several thousand dollars, and my daughter and her fiancé agreed to pay for the rest. (They both earn good salaries.) Lately, however, they've been hinting that they're "going to need a little more help," because the wedding is turning out to be more expensive than they'd thought. My husband and I really aren't prepared to give them any more financial assistance than what we've pledged. What do you suggest?

A: Have a respectful conversation in private—just you, your husband, and your daughter. (Suggest that the groom have the same conversation with his parents, if he wishes.) Explain that while you're delighted to be contributing to the wedding, you're already paying as much as you feel you're able to. Add that you're willing to work with your daughter and her fiancé to find creative ways to bring down expenses, while still having the wedding of their dreams. Bottom line, be very clear about exactly how much you can pay. The bride and groom, in turn, need to understand this and be grateful for the help being offered.

A Mom's Primer: Traditionally, Who Pays for What?

As a reference, below is a checklist of the *traditional* expense responsibilities of all the various aspects surrounding a wedding celebration. Keep in mind that these days, **all of the following guidelines are variable—depending on the particular circumstances of the wedding.**

Traditional Expenses of the Bride and Her Family

◯ Services of a professional wedding consultant N\A

◯ Invitations, enclosures, and announcements

◯ The bride's wedding gown and accessories

- Floral decorations for ceremony and reception, bridesmaids' flowers, bride's bouquet
- Formal wedding photographs and candid pictures
- Video of wedding
- Music for church and reception
- Transportation of bridal party to and from the ceremony
- All reception expenses
- Bride's gifts to her attendants
- Bride's gift to groom
- Groom's wedding ring
- Rental of awning for ceremony entrance and carpet for aisle
- Fee for services performed by sexton
- Cost of soloists
- Services of a traffic officer
- Transportation of bridal party to the reception
- Transportation and lodging expenses for officiant if from another town and if invited to officiate by bride's family
- Accommodations for bride's attendants
- Bridesmaids' luncheon

Traditional Expenses of the Groom and His Family
- Bride's engagement and wedding rings
- Groom's gift to bride
- Gifts for the groom's attendants
- Ties and gloves for the groom's attendants, if not part of their clothing rental package
- The bride's bouquet (only where it is local custom for the groom to pay for it)

- ○ The bride's going-away corsage
- ○ Boutonnieres for groom's attendants
- ○ Corsages for immediate members of both families (unless bride has included them in her florist's order)
- ○ The officiant's fee or donation
- ○ Transportation and lodging expenses for the officiant, if from another town and if invited to officiate by the groom's family
- ○ The marriage license
- ○ Transportation for the groom and best man to the ceremony
- ○ Honeymoon expenses
- ○ All costs of the rehearsal dinner
- ○ Accommodations for groom's attendants
- ○ Bachelor dinner, if the groom wishes to give one
- ○ Transportation and lodging expenses for the groom's family

Bridesmaids'/Honor Attendants' Expenses
- ○ Purchase of apparel and all accessories
- ○ Transportation to and from the city where the wedding takes place
- ○ A contribution to a gift from all the bridesmaids to the bride
- ○ An individual gift to the couple
- ○ Optionally, a shower or luncheon for the bride

Best Man's/Groomsmen's/Ushers' Expenses
- ○ Rental of wedding attire
- ○ Transportation to and from the city where the wedding takes place
- ○ A contribution to a gift from all the groom's attendants to the groom
- ○ An individual gift to the couple
- ○ A bachelor dinner, if given by the groom's attendants

Out-of-Town Guests' Expenses

- ◯ Transportation to and from the wedding
- ◯ Lodging expenses
- ◯ Wedding gift

big~ticket cost cutters

The best way to avoid running over budget is to rein in the cost of the big-ticket items—particularly the reception. Here are general tips on how to do this (you'll find additional cost-cutting ideas in later chapters):

- Number one cost-cutting tactic: Reduce the size of the guest list.

- Choose a less expensive reception site. Wonderful nontraditional choices include public gardens, historic homes and sites, museums and aquariums.

- Choose a time of year, a day of the week, or a time of day when prices are not at a premium.

- Avoid paying for unwanted extras. A package that includes printed napkins and matchbooks has less value if the couple doesn't care about those incidentals.

- Let friends help, with the understanding that their service is their wedding gift.

- Check Web sites for discount or wholesale bridal services.

- Comparison shop. Don't simply hire the first vendor interviewed.

- Hire a wedding consultant. Wedding consultants often have access to quality services at competitive prices and may also receive frequent-user discounts.

Tips on Tipping

Always ask whether gratuities are included before signing any contract. Often a caterer's gratuities are imbedded in the total costs; many hotels include a service charge for the waitstaff and possibly other employees such as parking valets. It's wise to set aside 15 percent of the reception budget as an unexpected tip fund. While there's no need to tip the wedding consultant, club manager, caterer, florist, photographer, or videographer, the gratuity budget should include amounts for the following tips:

* Valet parking (flat fee or $1 per guest)

* Coat-check attendants (flat fee or $1 per guest)

* Powder-room attendants (flat fee or between 50 cents and $1 per guest)

* Waitstaff and table captains (15 to 20 percent of bill)

* Bartenders (15 to 20 percent of bill)

* Limousine drivers (20 percent of bill)

guests and gifts

~☙ THE GUEST LIST ❧~

Planning at a Glance

Just for Moms

○ Confirm size and division of the guest list with the bride and groom.

○ Develop your own preliminary guest list—including full names (now is a good time to gather the correct spellings), addresses, phone numbers, and e-mail addresses.

○ Be ready (as needed) to help the couple decide on whom to invite from their families, including children.

For the Couple

○ Determine how many people your ceremony and reception site choices can comfortably accommodate.

○ Decide how intimate you want the wedding to be.

○ Decide whether to include children and/or guests of single friends.

○ Determine how the guest list will be divided.

○ Get names, addresses, phone numbers, and e-mail addresses of all invited guests.

○ Create a master guest list.

○ Identify overnight accommodation options for out-of-town guests.

○ Explore babysitting options, if needed.

○ Send information packets to out-of-town guests.

Whom to Invite?

Drawing up the guest list is one of the most challenging aspects of planning a wedding. The key is to think through the process carefully and make sure there's good communication between you and your spouse, the couple, and the parents of your child's fiancé(e). The best approach is to divide the process into two steps: First, determine how many people are going to be invited to the wedding. Next, decide how this number will be apportioned between the couple and their respective families (meaning you). Once these issues have been decided, you'll all be ready to draw up a master guest list.

Determining How Many People to Invite

The size of the guest list will depend on several factors: the level of intimacy desired, the size of the budget (in general, guests account for about half the cost of a wedding), and the number of those near and dear to the bride and groom and their families. To develop a reasonable estimate, start by assisting the bride and groom in answering these questions:

- How many people can the ceremony and reception sites comfortably hold?
- How important is intimacy?
- What is the total budget (see "Setting a Budget Ceiling and Splitting Expenses," page 20)?
- Do the bride and groom want to invite children?
- Do they plan to have single friends bring guests?

If space and budget aren't an issue — and the bride and groom aren't inclined to have a small, intimate gathering — then a total guest list of 200 or more is not out of the question. If either space or budget are limited or intimacy is a paramount concern, the guest list will need to be pared down, possibly to 100 or fewer.

If you're planning to invite children and/or guests of single friends, you'll also need to gauge approximately how many children or guests will actually attend, and add this number to your estimate. In addition, remember to include the officiant and his or her spouse or partner, the couple themselves, both sets of parents, and the wedding party.

Dividing Up the Guest List

Traditionally each family is allotted half of the total guest count. This list is usually divided in one of two ways: either into quarters, with the bride's family, the groom's family, the bride, and the groom each inviting one-fourth of the guests, or into thirds, with the bride's and groom's family each inviting one-third and the bride and groom inviting the remaining third. Of course, these percentages might vary greatly, depending on the location of the wedding, who is paying, family size, stepfamilies, and whether the wedding is the first one for the bride and groom.

Drawing Up Your Own Partial List

Once the size of your own portion of the guest list has been established, begin filling in the names of friends and family you'd like to invite. Start by drawing up a rough list of must-have guests, supplemented by "hopefuls" to be invited if there's enough room.

As soon as your own partial list is completed, give it to the bride and groom. Your list, combined with the lists of the other parents and the couple, will make up the master guest list.

STRESS-BUSTING TIP

supply your own addresses

To save the bride and groom added work, include the full names (correctly spelled), addresses, phone numbers, and e-mail addresses of everyone on your list. Be sure to keep a backup copy of this information in your own files, in case you need to contact someone on the list—or the couple's copy gets misplaced!

A Mom Wants to Know...

In my discussions with mothers, I've discovered there are certain questions that moms are often asked to weigh in on. Here are some suggestions on how to respond when your daughter (or son) calls to ask...

- **Do we invite children — or not?** Encourage the bride and groom to see that there are various possible scenarios. They could include children of family members only or children of a certain age (13 or older, for example) or no children at all. Another alternative is to let children attend the ceremony, then arrange for a child-care provider to feed and entertain them away from the reception site. The couple's particular circumstances and wedding plans will guide them to the right answer for their own wedding. Just be sure to stick to this decision, since making exceptions could lead to hurt feelings.
- **Must guests' partners be invited?** Committed partners of invited guests must be included in a wedding invitation. This includes couples who are married, engaged, or living together — whether anyone in the wedding party knows them or not. A single invitation addressed to both members of a married couple, or a couple who live together, is sent to their shared address. Invitations to an engaged or long-standing couple who don't live together are sent separately, to each address.
- **What if a guest asks if they can bring along a friend or a date?** The answer is straightforward: It is impolite of a guest to ask if he can bring a date — but it is not impolite of the couple to refuse. They can simply say, "I'm sorry, Stan, but we have very limited seating at the reception, and we just can't accommodate any additional guests." Allowing single guests who aren't attached to a significant other to bring a date is a thoughtful gesture, but it is not required and often not realistic. Envelopes addressed to a single friend "and Guest" indicate that he or she may bring a friend. If a single guest becomes engaged or reunites with a separated spouse after the invitations have been mailed, the bride or groom can extend a verbal invitation to the guest's fiancé(e) or spouse.
- **Should invitations be sent to out-of-town guests who probably can't attend?** Many people prefer not to send invitations to people whom they think won't be able to attend. In many cases, it may make sense instead to send these folks a wedding announcement, which carries no gift obligation. However, some good friends who live far away might actually

be hurt if you don't invite them, even if your intent was to spare them from feeling obliged to send a gift. Bottom line: *Always invite truly good friends* —even if they live far away.

When Kids Are Guests

If the couple decides to include children in the wedding, they'll want to ensure that the occasion is special for them, too. Here are some ideas for a kid-friendly reception:

Toys and Games

Have a piñata, filled with inexpensive toys. Set up a designated children's table with coloring books and favors. If children are seated with parents, provide each with a coloring book and small box of crayons.

A Kids' Menu

Include some kid-friendly foods such as chicken fingers, mini-ravioli, or pizza. Many reception sites and caterers offer a children's menu, which often costs significantly less than an adult meal.

Arrange for an Entertainment Room

Some reception sites provide a separate room where children can be entertained. Fill the room with toys, games, coloring supplies, a television and DVD player, a selection of DVDs, and snacks.

Hire a Babysitter

If young children are attending, have one or more qualified babysitters available on-site to care for them, in the entertainment room or elsewhere.

Hire a Child-Care Service

Companies now exist that will come to the wedding reception location and set up a fully staffed and organized kids' room. While adults are dining and dancing, children engage in age-appropriate activities and crafts.

MOTHER'S ETIQUETTE ALERT

when out~of~town guests bring kids along

Sometimes out-of-town guests aren't able to leave their children at home—even though kids aren't invited to the wedding. If so, provide them with names of some reliable babysitters in the area who will be available to watch their children during the wedding. In the case of a close relative whom you're counting on to attend, you might go a step further and arrange for a babysitter yourself.

Accommodations for Out-of-Town Guests

Out-of-town guests normally pay for their own lodging, unless they're members of the wedding party. It's thoughtful, however, to help out-of-town guests find places to stay. Some tips:

- You can pre-reserve a block of rooms in one or more hotels. If enough rooms are booked, discount rates are often available. Note: To ensure that you have all the rooms you'll need, do this as early as possible.
- Once potential hotels have been identified, consider the following before deciding to book a block of rooms: hotel condition, ambience, and amenities; distance from the ceremony and reception sites; distance from the airport; whether an airport shuttle is available; block rate information, including the cutoff date for guests to book rooms at the special rate.
- If friends offer to put up out-of-town guests at their homes, ensure that all involved are comfortable with the arrangement and that the hosts and the

guests are a good match. Remember, too, that you—or the couple—need to thank each host with a thank-you note, preferably accompanied by a small gift.

Once the accommodations have been chosen, mail or e-mail the following information to out-of-town guests (it can also be posted on the wedding Web site, if the couple has one):

1. The name of the hotel(s), along with address, phone number, e-mail address, and contact person
2. Directions from the hotel to the ceremony site
3. Information on which airlines fly into the closest airport
4. Information on car rentals and other ground transportation
5. An area map
6. Brochures or a list of local tourist attractions

When accommodations have been selected, enter them in your Address Book (page 136).

Making Out-of-Town Guests Feel Welcome

Although it's certainly not obligatory, it's a nice touch to offer out-of-town guests a list of possible activities during their stay—local tours, museums, points of interest, golf and tennis and other recreational facilities, and so forth—as well as the names of shops and restaurants they might enjoy. You and the couple might even plan some special outings for visiting guests.

STRESS-BUSTING TIP

information, please

Assembling and sending out information packets to out-of-town-guests is a great way for moms of the bride (or groom) to pitch in and lighten the couple's load.

ALL ABOUT
~WEDDING INVITATIONS~

Planning at a Glance

Just for Moms

○ *Confer with bride and groom on the wording of invitations.*

○ *Offer to serve as an "extra set of eyes" in proofreading the invitation text before it is sent to the printer.*

○ *If envelopes are being addressed by a calligrapher, double-check spelling of all names on your own partial guest list before submitting.*

○ *If the couple is addressing envelopes themselves, offer to help address, assemble, and send out invitations, especially those on your own partial guest list.*

○ *Offer to send out any wedding announcements.*

For the Couple

○ *Research invitation vendors and select a printer.*

○ *Decide on your preferences for invitation style, the weight and shade of the paper, and the printing process, typeface, and ink color.*

○ *Firm up your guest list. Get an accurate count of how many invitations you will need.*

○ *Gather information for maps, directions, parking, and other informational enclosures.*

○ *Finalize wording for the invitation and all other printed materials.*

○ *Get an itemized cost breakdown from the printer.*

○ *Order invitations, enclosures, announcements, and any other stationery or wedding favors. Establish a deadline for delivery or pickup. If the delivery time is considerable, ask to receive envelopes early so they can be addressed in advance.*

○ *Hire a calligrapher, if desired, and coordinate a time frame for addressing invitations.*

○ *Carefully check and proofread your invitation proofs on receipt.*

○ *Address outer envelopes and assemble invitations.*

○ *Buy postage on the basis of the weight of a completely assembled invitation. Mail all the invitations at the same time.*

○ *Make a list of people who should receive a wedding announcement. Delegate the mailing of announcements.*

"You're Invited..."

It's always a special thrill to get a wedding invitation in the mail. An invitation communicates the couple's excitement over the upcoming union and provides the first intimation of what the wedding will be like. While the choice of invitation style and printer is up to the couple, they may ask you to weigh in on the decision process. Either way, it's important to begin the ordering process as soon as the wedding date and sites are known. Printers can take several weeks or longer to fulfill invitation orders—and the invitations themselves need to go out at least eight weeks in advance of the big day.

Wedding invitations come in a variety of styles: third-person formal; nontraditional or informal; or, in the case of an intimate wedding, handwritten notes on beautiful stationery. The main considerations are the weight, shade, and dimensions of the paper; the printing process; the typeface; and the wording.

Formal Invitations

Formal invitations are traditionally printed on the first page of a double sheet of heavy ivory, soft cream, or white paper, usually $5\frac{1}{2}$ by $7\frac{1}{2}$ inches when folded—or on a smaller single sheet of heavy-weight paper. The ink is black and typically set in a shaded or antique Roman typeface. *Engraving,* which results in raised print, is the most traditional formal printing style. The shinier (and less expensive) raised print of *thermography* is also acceptable.

Wording for Formal Invitations Issued by the Bride's Parents

Third-person wording is the rule for formal invitations. The most common wording:

Mr. and Mrs. Richard Theodore Stevens
request the honour of your presence
at the marriage of their daughter
Deborah Lynn
to
Mr. Thomas Moore Jenkins
Saturday, the twenty-eighth of June
Two thousand and eight
at three o'clock
All Souls Episcopal Church
New Rochelle, New York

When Divorced Parents Give the Wedding Together

If relations between the bride's divorced parents are so friendly that they end up sharing the wedding expenses and acting as co-hosts, both sets of names should appear on the invitation (along with the names of their spouses, if either of them has remarried). The bride's mother's name appears first:

Mr. and Mrs. Curtis Samuels
and
Mr. Frederick Miller
request the honour of your presence
at the marriage of
Sarah Jane Miller
to
Stephen Lee Epstein
Sunday, the twenty-second of June
Two thousand and eight
at half after six o'clock
Temple Beth-El
Paramus, New Jersey

Some couples may choose to include both the bride's and the groom's parents on the invitation—especially if the groom's family shares in the wedding expenses. In this case, the bride's parents' names are given first:

Mr. and Mrs. Todd Gitlin
and
Captain and Mrs. Alfonse Siera
request the honour of your presence
at the marriage of
Barbara Gitlin
and
Luis Siera
Friday, the seventh of September
Two thousand and seven
at three o'clock
Riverside Gardens
Baton Rouge, Louisiana

Nontraditional or Informal Wedding Invitations

Less traditional invitations needn't adhere to the third-person wording style, nor must they conform to any set dimension. They may be printed on paper that incorporates a design, border, or even photos and be of any color the couple desires. They can also be handwritten or in any print style that appeals. In short, anything goes—within the limits of good taste, of course!

To evaluate and compare printers, use the "Comparison Chart" worksheet (page 123). When a printer has been selected, record the name and contact information in your Address Book (page 136). Keep track of printing expenses with the "Invitations and Other Printing Costs Breakdown" worksheet (page 132).

will people be offended by my daughter's "creative" invitations?

Q: My daughter and her husband-to-be are planning to design and manufacture their own wedding invitation on lavender paper. It includes some irreverent quotations and baby pictures of themselves. While I applaud their creativity, I was really hoping for a classic engraved invitation. I'm also afraid certain friends and relatives may be offended by the informality. Should I say something before it's too late?

A: Certainly, speak up—but do so delicately, and only after carefully considering whether their planned invitation is in sync with the style of their wedding. If it is, then your best approach is to relax and "go with the flow," realizing that stylistic boundaries are broader these days than they used to be. For example, invitations on colored paper are now considered perfectly fine for all but the most traditional and formal weddings.

If your daughter's wedding is going to be informal, I recommend you tread lightly. You might encourage them to keep their invitation uncluttered, by suggesting they cut back on the quotations and photos. Alternatively, they could use the photos on invitations to a shower or to the rehearsal dinner—events that can benefit from a touch of whimsy.

For a semiformal or formal wedding, you could certainly suggest a more classic look. Invitations cue guests as to what kind of event to expect: There's a logic to sending out formal invitations for a formal wedding. So…share your concerns, but tactfully. In the end, it's their decision. And while unusual invitations may raise a few eyebrows, I sincerely doubt that anyone will be offended.

Four Essentials Before Ordering Invitations

1. **Finalize the guest list before placing the order.** The couple will need one invitation for each couple, each single guest, and (if possible) each child 13 or older.

2. **Don't forget the wedding party.** Invitations also need to be ordered for the officiant, the parents of the bride and the groom, and the wedding party. Add these names to the master guest list, so they're included in any head counts.

3. **Order extras.** Order at least a dozen extra invitations to save as keepsakes and send to forgotten guests, plus extra envelopes (as many as 25 to accommodate mistakes in addressing).

4. **Decide between one envelope or two.** Formal, third-person invitations are traditionally inserted into two envelopes. The outer envelope carries the return address (printed) and the recipient's address (calligraphed or handwritten). The inner envelope, which is left unsealed, bears only the names of the people to whom the mailing envelopes are addressed. As such it serves a useful purpose, by allowing the bride and groom to be very specific as to whom they're inviting ("Ms. Carol Smith and Guest," for example). Less formal or nontraditional invitations may be sent in one envelope only. In this case, it is especially important that the mailing address convey exactly whom the invitation is being sent to ("Mr. and Mrs. Chris Jackson, Emily, and Chris, Jr.," for example).

All About Insertions

In addition to the invitation, several types of cards may also be printed and sent with the invitation, as necessary.

- **Response card:** This card provides a space for guests to write their names and to indicate their acceptance or regrets. A response card is always accompanied by an addressed, stamped envelope for its return. It is also acceptable to include the option for guests to e-mail their RSVPs, if they prefer. A printed sentence can be added at the bottom of the card, such as *You may also reply by way of the e-mail address happycouple@rsvp.com.*
- **Reception card:** This is included when more people are invited to the reception than to the ceremony, or when the reception and the ceremony are held in different locations.
- **Map/direction card:** Generally for out-of-town guests only, these should be as concise and compact as possible to minimize bulk. Printed directions, especially with formal invitations, look the best.

- **Admission cards:** Included only when a wedding is held in a cathedral or church that attracts sightseers.
- **Pew cards:** Engraved with *Pew Number* _____ or *Within the Ribbon* to indicate reserved seating for close family and friends. Usually sent after acceptances are received.
- **"At home" cards:** Used to let friends know the bride and groom's new address.
- **Rain cards:** Notes the alternate location of the ceremony and/or the reception in the event of inclement weather.
- **Travel information:** Help for out-of-town guests. This can be sent after a response has been received or can be included with the invitation, perhaps laser-printed on a single sheet of stationery. The information may include suggested accommodations, the names of airlines that fly into nearby airports, ground transportation services, car rental information, even area attractions.

Printed Extras and Options

If their budget allows, the couple might also consider ordering the following:

- **Personal stationery:** Fold-over note cards, usually printed with the initial of the couple's last name (to be used by both the bride and groom) or the bride's name or initials on the front. Often ordered alongside invitations, to be used for thank-you notes.
- **Personalized favors:** Cocktail napkins, matchbooks, and other memorabilia printed with the couple's name or monograms—sometimes offered as reception favors but completely optional.
- **Save-the-date cards:** These advance notices help guests make their travel plans. They're typically mailed three to four months before the date, or earlier for a destination wedding at a popular resort or for a wedding on a popular holiday weekend.
- **Place cards:** Blank place cards for the reception may be ordered from the printer, to be filled in by hand later. (See "Place Cards," page 85.)
- **Ceremony programs:** These help guests follow the various parts of the ceremony, and make wonderful souvenirs. (See "Ceremony Programs," page 60.)

* **Wedding announcements:** Sent to friends and family who could not be accommodated on the guest list and to acquaintances or business associates who might wish to hear news of the marriage, these ideally should be mailed the day after the wedding. They may be sent in the name of the bride's parents (traditionally), or both sets of parents, as desired. (See "Preparing Announcements," page 110.)

(See "Preparing Announcements," page 110.)

MOTHER'S ETIQUETTE ALERT

assisting on invitations

If you really want to help out the couple, offer to take over the addressing and assembly of the invitations—or at least those for your own guest list. One note: If the invitation duties are split up—between the couple, the mother of the bride, and the mother of the groom, for example—be sure all are mailed at the same time. (Sending some later than others might inadvertently suggest to recipients that their invitations were an afterthought.)

Addressing Addresses

Double-check the names on your guest list before the envelopes are addressed, to be sure they are spelled correctly. Invitations are always addressed to both members of a married couple. An invitation to an unmarried couple residing at the same address should be addressed with each name on a separate line. No abbreviations or initials are used when addressing formal invitations. If children are invited but are not receiving a separate invitation, their names may be written on a line below their parents' names on the inner envelope. If no inner envelope is used, children's names are written on the outer envelope along with the names of their parents.

The couple should also carefully consider where they want their RSVPs sent. Remember, unless they include a response card (see below) or list a different RSVP address inside the invitation, responses and gifts are likely to be sent to the return address on the outer envelope.

Assembly and Mailing Tips

* Allow plenty of time to carefully address, assemble, and mail all invitations.

* Organize the master guest list in useful form, such as on file cards, in a computer database, or in the "Wedding Guest List" worksheet on page 119.

* Before buying stamps, have a completely assembled invitation (or two variations: one for local guests, another for out-of-town guests that may include additional enclosures) weighed at the post office to determine correct postage.

* Look for attractive stamps that will complement the look of the wedding invitation envelope.

* A folded formal invitation is properly placed into the inner or outer envelope folded end first, with the printed side facing away from the front of the envelope.

* If the invitation is on a single sheet, it should be placed into the inner or outer envelope with the printed side facing the front of the envelope.

* Insertions go on top of the printed side of the invitation inside the inner envelope (if used) or outer envelope. Tissues are optional.

* If response cards are used, lightly mark the back of each card with an identifying number in case guests neglect to write in their names when RSVPing.

* Before sealing the outer envelope, double- and triple-check that the names on the inner and outer envelopes match up.

STRESS-BUSTING TIP

fielding RSVPs

One valuable way a mom can help in the run-up to the wedding is by offering to have the wedding invitation RSVPs sent to her address. This relieves the couple of the task of keeping track of who's responded and who hasn't, and of who's coming and who isn't. Simply keep a copy of the master guest list close at hand (see "Wedding Guest List" worksheet, page 119) when you're opening the day's mail and check off the replies as they flood in.

Gifts, Registries, and
~ Thank-You Notes ~

Planning at a Glance

Just for Moms

○ *Tell guests via word of mouth where the bride and groom are registered.*

○ *Be prepared to receive and hold gifts sent prior to the wedding.*

○ *Offer to help the couple keep track of gifts received.*

For the Couple

○ *Make a list of items you want or need.*

○ *Open registries in the stores and on the Web sites of your choice.*

○ *Create a master list of gifts received, including sender's name and address, the date the thank-you note was sent, and any exchanges.*

○ *Write thank-you notes for gifts as you receive them.*

"Where Are They Registered?"

Once the couple has chosen the stores they want to register with, enter this information in your Address Book (page 136). You'll need it: Mothers of the bride or groom have a major role to play in letting guests know where the couple is registered. This important information should always be spread by word of mouth. Wait until someone asks you, then pass along the name of the stores and how to access their registry lists (many stores post couples' lists online). Make sure guests have the full names of both the bride and the groom, as well as the wedding date.

Arranging for Gift Delivery

Wedding gifts are generally delivered to the bride's home or to the home of her parents before the wedding, addressed either to the bride or the couple. If gifts are sent to your home, you can be a tremendous help to your daughter or son by informing them of each gift as it arrives. Set up a reliable method for keeping track of gifts, so the couple can stay up-to-date on who they need to thank. Gifts sent after the wedding are usually shipped directly to the couple at their new address. Be sure to have copies of this delivery information on hand to give to stores (and also to guests, if necessary).

Keeping a "Gifts Received" Record

One invaluable service moms can perform is to help the couple keep track of wedding gifts as they come in. The Wedding Gift Record on page 121 can be photocopied as many times as necessary, and you and the newlyweds can use the blank pages to record each gift. Include the date when the gift was received, the name and address of the giver, the store the gift came from, if known, and what the gift is. When describing the gift, be as specific as possible: Writing "serving tray" won't help if the couple receives three. The gift record also includes a column to indicate the date on which a thank-you note for each gift is sent out and a column for numbering each gift.

MOTHER'S ETIQUETTE ALERT

no registry info in the wedding invitation, please!

Lists of registries should never be included in the wedding invitation. Guests tend to find such enclosures offensive because they place an undue emphasis on gifts, rather than on the act of inviting. For the same reason, registry lists should not be included in engagement party invitations or wedding announcements. It is appropriate for shower hosts to include registry information in their invitations, since gift-giving is the highlight of a shower. [See "Showering the Bride (and Groom)," page 51.]

thinking outside the box

The bride- and groom-to-be probably have plenty of ideas about where to register, but it's worth reminding them that while the tradition of registering for china, silver, and crystal is as popular as ever, couples are increasingly turning to nontraditional registries such as discount retail outlets, garden and home centers, recreational/sports stores, charities, travel agencies (for honeymoon funds), and investment and/or mortgage accounts. Wherever the couple registers, they should select items in a range of prices, so that guests have choices that fit their budgets. For the convenience of their guests, they should also try to register at places where their registry will be accessible online for review and making purchases. (Most large stores now offer this option.)

A Mom's Thank-You Note Primer

Some subtle (or not so subtle!) tips for the bride and groom:

* Every gift—whether it's an expensive item or a gift of time, energy, or personal expertise, must be acknowledged with a separate, handwritten note.

* Every thank-you note, no matter how short, should include a reference to the gift and an expression of appreciation for the thought and effort that went into it.

* A note of thanks should also be sent to those who send congratulatory telegrams on the day of the wedding.

* Write neatly, and keep each note "short and sweet"—three to five sentences is plenty.

* To aid in penning prompt replies, have note cards or stationery and postage stamps on hand, and address and stamp the thank-you note card envelopes in advance. (This is another task moms can offer to help with.)

* Time frame for writing thank-you notes: As soon as possible, and *always within three months of receipt of a gift—at most.*

- Grooms write thank-you notes these days as well.

- It's inappropriate to send preprinted thank-you cards with no personal message added.

- The couple should **never** let on if they dislike a gift. When writing a thank-you note for a gift that's been exchanged—either because it's a duplicate or just not desired—they should simply thank the giver for the original present. There's no need to mention that the gift has been exchanged for something else.

~⟩⟩⟩ SHOWERING THE BRIDE ⟨⟨⟨~ (AND GROOM)

Planning at a Glance

Just for Moms

○ Determine who is planning to host a shower for the bride or the couple.

○ Confer with the couple to come up with a guest list for the host(s).

For the Couple

○ When asked, prepare a shower guest list for anyone planning to host a shower.

○ Thank everyone who gave gifts, both in person and again in writing.

○ Give a thank-you gift to the host(s), then follow up with a thank-you note.

Wedding Shower Basics

A wedding shower is an intimate gathering of friends and family to extend warm wishes and "shower" gifts on the bride or the couple. While in the past it was considered self-serving for an immediate family member to throw a shower, these days it's perfectly acceptable for the mother (or sister) of the bride or groom to host a shower—particularly if the bride is visiting her future in-laws and the groom's mother wants hometown friends to meet her. Alternatively, a shower may be hosted by a good friend of the couple or friends of the couple's parents. One ironclad rule: A couple never hosts a shower for themselves.

A Mom's Wedding Shower Primer

Whether you're hosting a shower or attending a shower that's being hosted by someone else, here are some tips to keep in mind:

* **Format.** A shower can take any form the host chooses—a casual gathering with light snacks, a brunch or supper (sit-down or buffet), an afternoon tea, or an evening get-together. The honoree should be consulted about the date, time, and guest list (unless the shower is a surprise), but the actual party planning is left up to the host.

- **When is a shower held?** Ideally the shower should be scheduled two months to two weeks before the wedding, after the couple has firm wedding plans. It may be held on any day that's convenient for the guest of honor, the hostess, and the majority of guests.
- **Who is invited?** The guests are generally close friends, attendants, and family members. These days, couples showers—attended by both women and men—have become increasingly popular. Normally, anyone invited to a shower should also be invited to the wedding. One exception is when coworkers throw an office shower for the bride. In this case, it's usually understood that attendees will not necessarily be invited to the wedding.
- **Is it all right to hold more than one shower?** As a general rule, two wedding showers are the limit (excluding office showers), with different guests invited to each. Parents, close family members, and wedding attendants can certainly be invited to more than one shower, but it should be made clear that they're not expected to give more than one gift.
- **How should invitations be issued?** Usually the hostess sends out handwritten notes or preprinted invitations with the details filled in. Invitations may also be issued in person, over the phone, or via e-mail.

Record info on all bridal showers in your Address Book (page 136). To keep track of guests, use the "Party Guest List" worksheet (page 120).

ASK PEGGY

shower no-shows

Q: *A gala couples shower was recently thrown for my son and his fiancée. Two of their invited friends who couldn't attend did not bother to RSVP and also failed to send gifts. Were they right to be upset?*

A: Tell your son and future daughter-in-law that their friends' correct-to-erroneous ratio was actually 50:50. Whenever an RSVP is requested, it's always a no-no to ignore it—but those who do not attend a shower are *not* obligated to send gifts (though close friends might choose to send a gift anyway).

it's raining showers!

Q: My daughter wants to let several of her friends hold four separate showers in her honor and wants her attendants and other close friends to be invited to every shower. I'm worried that she's putting an undue burden on these guests by expecting them to buy multiple gifts and spend so much time going to parties. What should I do?

A: Have a low-key talk with her, pointing out your concerns and suggesting some possible solutions. Maybe two or more of the friends could co-host an event—or maybe the invitation lists can be coordinated so that no guest is invited to more than two showers. Whatever's decided, you should advise your daughter to reassure her buddies that any guest attending more than one shower needs to bring a gift to only the first one. (If they prefer not to come to subsequent showers empty-handed, suggest they bring something inexpensive such as a card, flowers, or homemade brownies.)

The Etiquette of Shower Gifts

While the opening of the presents is usually the high point of the shower, the real purpose is to assemble good friends to celebrate the upcoming marriage. Here are some gift guidelines to keep in mind:

* In general, shower gifts should be relatively inexpensive. Homemade gifts, such as a collection of recipes, are perfectly okay.
* Shower guests can purchase gifts from the wedding registry if they choose. While you shouldn't include registry information on the invitation, it's fine to enclose it on a separate sheet. The host can also make recommendations to people who ask for gift suggestions.
* Some showers focus on a specific theme, such as kitchen showers (glasses, knives, utensils, etc.), cooking showers (gourmet foods and wines, cookbooks), spa showers (massage certificates, aromatherapy oils, candles), and lingerie showers. Any shower theme should be noted on the invitation. For lingerie showers, include the bride's sizes as well.

- Gifts are generally opened after refreshments have been served. The guests gather around while the bride (or couple) opens the packages one by one and thanks the giver. The gifts are then typically passed around the room so that everyone can see them.
- The bride (or couple) should give the host a thank-you gift — then follow up with a note.
- The bride (or couple) should send thank-you notes to all shower guests — even if they've already been thanked in person at the shower. As a mom, you can help the couple keep track of who gives what by using the Shower Gift Record on page 122 to record all shower gifts.

STRESS-BUSTING TIP

easing the strain on guests' budgets

Shower gifts, combined with wedding gifts, can place a real financial strain on wedding guests. If this is a concern, you might suggest a low-priced gift theme. Some possibilities:

- Book, CD or DVD showers: Perfect for lovers of reading, music, and movies.

- Recipe showers: Favorite recipes are written on recipe cards and collected in a box or file.

- Pantry showers: Useful and/or exotic pantry supplies, such as spices, condiments, coffees, and teas.

- Stock-the-bar showers: Basic bar components, such as measuring utensils, bottle openers, swizzle sticks, cocktail napkins, and tins of nuts.

the ceremony and reception

PLANNING THE CEREMONY

Planning at a Glance

Just for Moms

❍ Confer with the bride and groom on their choice of ceremony site and officiant.

❍ Review ceremony details with the bride and groom.

❍ Confirm seating arrangements for members of the immediate family.

For the Couple

❍ Select and reserve the ceremony site as soon possible after the engagement is announced.

❍ Meet with the officiant to discuss the ceremony and rehearsal details, including personal elements such as special vows or readings. Inquire about any site restrictions on music, photography, videography, and flowers.

❍ Meet with the organist or music director and any other soloists/musicians to discuss the musical components of the ceremony (see "Striking the Right Note: Music for the Ceremony," page 98).

❍ Prepare and print the ceremony program (if desired) in the weeks prior to the wedding.

❍ Schedule the rehearsal, preferably for the day prior to the wedding.

The Heart of the Matter

The wedding ceremony is the true centerpiece of the celebration—and the one place where collaboration between you and the bride and groom is essential. It draws on centuries of custom and family traditions, and its memory will linger forever. That's why everyone—the couple, you, the other parents, and the officiant—has to be in full agreement on the details.

suggesting a ceremony site or officiant

Is there a traditional family house of worship that you have your heart set on seeing your child married in—or an officiant especially close to your family, whom you would dearly love to perform the ceremony? If so, raise these options early—but only as suggestions. Since the ceremony is a family affair, this is one area where it's appropriate to let your preferences be known to the couple in a private conversation: "I'd love it if the two of you would consider holding the ceremony at St. Thomas's. It would mean a lot to us! And if you do hold it there, I'm sure Father Kincaid would perform the ceremony if you wanted him to."

Your child might agree with your dreams—but be prepared for the fact that the couple might have something else in mind. Perhaps the wedding is going to be one that merges two faiths, or maybe the couple prefers a secular ceremony. Once you've made your desires clear, you should leave the final choice up to the couple—then abide gracefully by whatever they decide.

Selecting the Ceremony Site

You can help the couple by encouraging them to decide as soon as possible on a place and approximate date for their nuptials. The first major decision is whether to get married in a house of worship or in a secular setting. In either case, play it safe by *reserving a few dates*, if possible, until the reception site and date have been pinned down. If the site is well known, there are likely to be competing requests to use it—especially if the wedding is slated for a popular time, such as late spring or early summer. The couple then needs to make their final decision

promptly so that the place and date can be confirmed (and the unneeded dates canceled). Once the couple has decided on the ceremony site, enter it into your Address Book (page 136).

Key Things to Know About the Ceremony Site

Here are some important points that the couple (and you) should know before making a decision:

- Is the site large enough to hold all of the invited guests?

- If temporary seating is being installed (in a garden or at the reception site, for example), are enough seats available, and will the setting be sufficiently private?

- If the ceremony is held at a house of worship, are there any restrictions on what readings can be used, and can a visiting officiant perform the ceremony if desired?

- Is there an organist or music director who will be in charge of the music for the ceremony?

- Are instrumental and/or vocal soloists permitted?

- Are there any restrictions on the music that can be played before, during, and after the ceremony?

- Are there any restrictions on photography and videography (including the use of lights) or on what floral arrangements can be used?

- Are any other weddings scheduled at the ceremony site that day? If so, how will this affect the timing of your ceremony?

- Is a room available for dressing prior to the service?

- Is there plenty of parking available, as well as easy access for cars carrying the wedding party and any elderly or handicapped guests?

- Are there any restrictions on throwing rose petals, rice, or birdseed outside the house of worship, and can the flower girl scatter rose petals inside?

- Is an aisle carpet or runner provided?

- For a Christian ceremony: May or must communion be part of the ceremony?

- For a Jewish ceremony: Who will provide the *chuppah,* and may it be decorated with flowers?

- Are there any restrictions concerning dress, such as bare shoulders or arms and/or head coverings?

- If the ceremony is not conducted in a house of worship, are there any restrictions on the kind of ceremony you can have, and will you need to provide an altar and/or altar cloth, a kneeling bench or cushions, candles, or any other liturgical items?

STRESS-BUSTING TIP

outdoor wedding? line up a foul-weather alternative!

There's nothing more beautiful than watching your child say her or his vows on a lush green lawn, surrounded by budding trees and blooming flowers. Just remember that rainstorms don't read the social calendar. *Always line up an alternate indoor location as a backup* when you reserve the ceremony site—then ascertain exactly how the ceremony will be shifted to the backup site if inclement weather strikes.

Selecting the Officiant

Once the ceremony date and location have been chosen, the next step is to decide who will preside over the ceremony. This, too, should be done well ahead of time, to ensure that the chosen officiant is available and to allow him or her time to make travel plans, if necessary.

If the ceremony is being held in a house of worship, it's likely that the clergyperson associated with the institution will be available to perform the ceremony. If you want a visiting officiant to perform the ceremony (a relative who is a clergyperson, for example), make this known when reserving the site.

Key Things to Ask the Officiant

* Is premarital counseling required or available?

* Does the officiant have a preferred marriage service — and if so, is he or she open to making changes in the service if desired?

* Approximately how long will the ceremony run?

* What role will the parents of the bride and groom play in the ceremony?

* Can the couple add their own readings and/or write all or some of their vows?

* Will the officiant arrange for other service participants, such as altar boys, altar girls, or acolytes?

* When will the rehearsal be held, how long will it last, and who needs to attend?

* Does the officiant have any travel needs? (Note: the couple traditionally pays travel and lodging expenses for a visiting officiant.)

Once the officiant has been selected, enter his or her name and contact information in your Address Book (page 136).

Traditional Ceremony Seating Arrangements

* Parents of the bride always sit in the first pew (or row of seats) on the left, and the parents of the groom sit in the first pew (or row of seats) on the right. (If one parent is widowed, he or she may prefer to be joined by a friend or relative, rather than sit alone.)

* Immediate family members of the bride and groom (grandparents, siblings and their spouses and children, aunts and uncles) sit in the pews immediately behind the couple's parents on the left and right sides, respectively.

* If the bride's or the groom's parents are divorced, they typically will not sit together. The mother (and stepfather, if she's remarried, or partner) sits in the front row, with close family members sitting in the pews immediately behind her. The father then sits in the next pew back, with his wife (if remarried) or partner and family members.

* In the case of extremely good relations between divorced parents, the

friendliest seating arrangement is for them to sit together in the front pew and for their spouse(s) or partner(s), if any, to sit there with them.

* If a divorced parent is unmarried and has a live-in partner, they may choose to sit together—but only if relations with the parent's ex-spouse are so amicable that it's certain no one will be offended.

MOTHER'S ETIQUETTE ALERT

seating family members

It will likely fall on you, as the mother of the bride or the groom, to be sure that there are enough reserved seats to accommodate close family members. Decide with the couple whom you want to fill these seats, then determine with the officiant or site manager how many rows will be needed and how they'll be set aside. (The first several rows on both sides of the aisle are sometimes marked off with a ribbon or cloth rope, which is removed just before the ceremony begins.) Take into consideration all of the variables (and emotions) of family dynamics when making seating arrangements, then choose what will make the most people feel comfortable.

To be sure all the ushers are aware of which family members should be escorted to these rows, review the seating plan carefully with them before the ceremony, including when the bride's and groom's immediate family members will be escorted to their seats. In addition, the ushers may be given a list with the names of close relatives and friends who get reserved seats—or these honored guests may be given cards themselves to hand to the ushers, indicating where they're to be seated.

Ceremony Programs

Having a printed program of the wedding ceremony is purely optional, but it can serve a number of purposes: Besides helping guests follow the service—and making a wonderful souvenir—it may also contain the names of musical pieces and the musicians performing them, the text of group prayers or readings, a poem or meditation on love and marriage, the names of those doing readings, and the names of the bride's and groom's attendants. Brief biographies of the bride and groom are okay. The program should *never* include advertisements for wedding service providers.

While it's possible to have programs printed by the same company handling the wedding invitations, a local print shop may cost substantially less, and the turnaround time may be much quicker—an important factor, since the wedding service often isn't finalized until well after invitations are ordered. You and the couple should arrange for the program elements to be delivered to the printer at least several weeks before the wedding day, and the finished programs to be delivered to the couple with at least a week to spare. Note: Some couples now design and print their own programs using computers and printers, buying special paper for the occasion. This saves money, and permits last-minute changes if needed.

To evaluate and compare printers, use the "Comparison Chart" worksheet (page 123). Once a printer has been selected, enter the information in your Address Book (page 136).

MOTHER'S ETIQUETTE ALERT
the long walk

The trip down the aisle may only be a few yards in actual distance, but it's one of the longest and most memorable walks that the bride and the parents of the bride and groom will ever make. If you (or the bride) have special wishes for the processional, then by all means make them known. For example, one mother whose only daughter was getting married fulfilled a longtime wish when she was escorted to her seat by her two sons (both ushers) on either side of her. Often, a bride will request that she be escorted down the aisle by both of her parents, rather than just her father. Or you, the groom's mother, or someone else may do the honors—as with the bride whose father was estranged from the family; she was instead walked down the aisle by her mother's brother. Finally, it's not at all uncommon—and is entirely appropriate—for the bride to make her graceful entrance down the aisle either alone or escorted by her child or children from a previous marriage.

It can be very exciting to plan your own special journey down the aisle. So enjoy the planning—and the walk!

ᚼᚬ Looking Your Best ᚬᚼ
for the Big Day

Planning at a Glance

Just for Moms

Mother of the bride:

○ Select your wedding-day outfit at least three months before the wedding date. Once your decision has been made, immediately contact the mother of the groom to let her know what you'll be wearing.

○ Help your daughter select her gown, if she wishes and if logistics allow.

Mother of the groom:

○ As soon as you learn what the mother of the bride will be wearing, select your outfit.

Both mothers:

○ Confer with your husband on his wardrobe.

○ Decide on your other wedding event outfits (for rehearsal dinner, any parties).

○ Make appointments with a hairdresser, manicurist, and makeup artist, as desired.

For the Couple

○ Select the wedding gown and accessories.

○ Select bridesmaids' gowns and accessories.

○ Schedule fittings.

○ Make or confirm any appointments with a hairdresser, makeup artist, and manicurist.

○ Confirm rentals or purchases (if necessary) for the groom and his attendants.

○ Schedule fittings as needed.

○ If possible, the bride (and perhaps her attendants) should do a trial run of makeup and hairstyle.

What's a Mother to Wear? (Almost) Anything

Naturally, you want to look terrific on the day your daughter or son gets married — because while it's true that all eyes will be on the bride, they'll also be on *you*. The old concept that both moms are supposed to look matronly was retired long ago, along with the adage that the mother of the groom should wear beige. These days, virtually anything goes — formal gown, short or long dress, skirt-and-jacket ensemble — so long as it matches the style of the wedding and stays within the limits of good taste. Some guidelines to keep in mind:

* Choose a color that will blend nicely with the dresses of the wedding party. Avoid matching the color of the bridesmaids' dresses exactly, although it's fine if your outfit is a variant shade of the color.

* Avoid wearing white. This color is reserved for the bride. If you want to wear a light color, choose a pastel in a light or medium tone.

* Choose a color and style that are flattering to your coloring and figure. The key is to feel really good.

* Traditionally, the bride's mother has the honor of selecting her outfit first.

* The mother of the groom, in picking her outfit second, should ideally wear a different color from that of the bride's mother. When in doubt, she should go with a soft or neutral color, rather than an excessively bold color.

* The mothers do not have to wear dresses of equal length, although many choose to do so in order to create a more harmonious look — especially in wedding photos.

* Gloves and hats are optional.

Wedding Outfit Wisdom

Your goal is to look great, without trumping the bride. This generally means steering away from anything too revealing or form-fitting. Many mothers opt for an A-line dress style, featuring a slight flare in the hips. Knee-length is fine for a low-key, less formal wedding. For a more formal affair, fashion experts advise that tea-length dresses, long popular, are less in vogue these days and rather hard to find. They recommend considering a full-length dress instead, with the hem touching the top of the foot. If you're intent on a tea-length look, you can have the dress shortened to the desired length. A few other tips:

- A specialty store, rather than a department store, will offer much more personalized attention throughout the process—from choosing a dress to making alterations to selecting just the right undergarments.

- If possible, bring in a swatch of the bridesmaids' gown material when you go shopping. Otherwise, have at least a description of the gowns' color.

- Silk crepe or silk chiffon dresses are generally recommended for the mothers of the bride and groom. For a semiformal wedding, the dress needn't be beaded or have elaborate lines. If the wedding is very formal, a brocaded or beaded fabric may be appropriate.

- Wedding separates are also increasingly popular. With these outfits, you can choose from a variety of tops and bottoms, each in the perfect size for you.

- Order your outfit at least two to three months ahead of time, and allow at least two weeks for alterations.

- Don't worry about matching shoe color to your outfit. These days, the trend is toward shoes with a more subtle neutral or burnished metallic hue that will blend with a dress rather than match it.

- When buying your dress, get specific advice on what undergarments will look best with it—such as a strapless low-back brassiere, a bustier, slimming pantyhose, and so on.

- As for who calls whom to discuss "our outfits," the mother of the groom shouldn't stand on ceremony; if she hasn't heard anything once the initial wedding plans are under way, she's perfectly welcome to call the mother of the bride.

ADVISER TO THE BRIDE AND GROOM

finding the perfect wedding gown

As the mother of the bride, you may be called on to join your daughter in the search for the wedding gown of her dreams, or you may be brought in later in the process to give a thumbs-up on her final choice. Either way, here are some tips for making the quest as smooth as possible:

• Begin looking for a wedding gown as soon as the date is set—and at least nine months in advance of the wedding, if possible. The selection, ordering, and

alteration processes can be lengthy. A custom-made gown, for example, may need to be ordered as much as a year in advance.

- The bride should clip pictures of gowns she likes from magazines to show a salesperson or wedding consultant the kind of style she's looking for.

- Visit different types of bridal stores—both bridal bargain outlets and higher-end salons—and always make an appointment in advance, so that the staff is prepared and available to help you.

- Encourage your daughter to try on various styles and not to rely on "hanger appeal" only. Many brides are pleasantly surprised when trying on a style they hadn't originally considered.

- When trying on gowns, she should be sure to wear the same type of lingerie and the same height shoes she plans to wear for the wedding.

- When asked your opinion, it's fine to express a preference—but steer clear of specific critiques, such as "That dress makes your hips look big."

- Above all, let the bride make her own final selection. Otherwise, it could breed resentment down the road.

- Consider hiring a seamstress to make the bridal gown. Ask reliable sources (friends, previous brides) for recommendations, plan far ahead (eight months or more), and always ask to see samples or photographs of the seamstress's work before signing a contract. There are pluses to having a one-of-a-kind gown that's custom-made for the bride alone. On the minus side: There's always a chance that the dress won't be completed on time or that the finished product won't look as great as envisioned. Also, going to numerous seamstress fittings is time-consuming.

- Once a gown has been selected, you—or your daughter—will sign a contract with the bridal salon that details the services provided. Find out up front if the cost includes alterations and pressing. (If pressing isn't included, it may be less expensive to have this done by an experienced dry cleaner.)

- The first fitting should be scheduled approximately four to five weeks before the date of the wedding or date of the formal studio portrait sitting (if one is planned). The gown delivery date should be set at least a few days before the wedding date or the formal portrait.

Once the maker of the bridal gown has been selected, enter the information in your Address Book (page 136).

air out that gown!

To be sure the bridal gown isn't musty or wrinkled on the big day, take it out of the garment bag several days in advance (leaving in any tissue stuffing in the sleeves and shoulders) and hang it from a high point with the train spread out on the floor over a white sheet. Then keep this area strictly off-limits to all food, beverages, young children, pets, or anything else that might cause damage or stains.

Picking a Dress That Bridesmaids Can Live With

Choosing bridesmaids' outfits can sometimes seem like a no-win situation: It's hard to pick a single dress that will please a number of women. Savvy mothers can help smooth the process by passing along the following tips:

- The bride should consider the price of the attendants' gowns carefully, since they're generally expected to pay for their own dresses and accessories. If the dresses selected are pricey, it's not unheard-of for the bride and/or her family to pick up part of the cost.

- Bridesmaids' dresses should match the bride's dress in degree of formality and material. If the bride is wearing satin, the attendants' dresses should be satin as well — not organdy or ruffled lace.

- Since bridesmaids come in all shapes and sizes, look for gowns that will flatter everyone. Get their input and be flexible. One increasingly popular option is to select a color and general style, then allow each bridesmaid to choose their own dress.

- All hemlines should be the same distance from the floor.

- If dresses are long, be sure the hemlines are short enough to prevent the attendants' tripping on altar or platform steps.

Dressing the Groom and His Attendants

For the men, the choice of attire is fairly straightforward.

- **Formal wear.** EVENING: A black tailcoat and matching trousers, stiff white shirt, wing collar, white tie, and white waistcoat. DAYTIME: Formal

day clothes are worn whenever a wedding is scheduled before 6 PM. The daytime equivalent of the evening tailcoat is a black or Oxford-gray cutaway coat worn with black- or gray-striped trousers, pearl gray waistcoat, stiff white shirt, stiff fold-down collar, and four-in-hand black-and-gray tie or a dress ascot tie.

- **Semiformal wear.** EVENING: Black or midnight-blue dinner jacket (tuxedo) and matching trousers, piqué or pleated-front white shirt with attached collar, black bow tie, and black waistcoat or cummerbund. In hot weather, a white dinner jacket and black cummerbund are often used. DAYTIME: A simple suit-style dark gray or black sack coat is substituted for the cutaway, the shirt is soft and not stiff, and only a four-in-hand tie is worn.
- **Informal wear.** Lightweight suits or dark gray or navy blue jackets accompanied by white trousers and either white dress socks and white dress shoes or black dress socks and black dress shoes. Shirts are soft white with attached collar, and ties should be four-in-hand with a dark, small, neat pattern.

The attire of the groom's attendants typically mirrors what the groom is wearing. The groom may send ushers his own outfit's specifications and ask each of them to rent similar clothing—or he may order all the outfits from a rental agency. Formal-wear rental stores will generally carry any needed accessories, such as cufflinks and cummerbunds. The groom, his groomsmen, and his ushers might also consider purchasing (rather than renting) tuxedoes.

STRESS-BUSTING TIP

swear by swatches

When ordering the bridal dress and attendants' gowns, ask the store or bridal salon to provide fabric swatches. These will help you coordinate the mothers' dresses, as well as shoes and flowers. The swatches can also assist the florist in creating complementary flower and decorating schemes.

Hair and Makeup

With all that's being spent on clothing, photography, catering, and the rest, why skimp on beauty? And remember, wedding photos last a lifetime! Here are some tips for the mother of the bride to keep in mind:

* When going to the hairdresser, it's a great idea for you and the bride to bring in photos of any hairstyles you like, as well as pictures of your outfit and the bride's gown and descriptions of anything the bride will be wearing in her hair. Also, convey exactly how you plan to style your hair at the wedding. All will influence the length of the cut and the coloring used.

* You and the bride should both arrange to have your hair done the morning of the wedding. If you like, you might also schedule a "dress rehearsal" with your stylist beforehand.

* Consider having a professional makeup artist do the makeup for you, the bride, the groom's mother, and (if desired) the bride's attendants. Preferably he or she will come to wherever the bridal party is getting dressed. The makeup process should begin several hours before the wedding. Allow at least 30 minutes per person being made up, and an hour or more for the bride.

* If possible, have an initial meeting with the makeup artist six months in advance to try out different effects. He or she can then prescribe a skin-care regimen so that your skin looks its best for the wedding.

If and when a hairdresser and makeup artist are selected, record their names and contact information in your Address Book (page 136).

⟶ᵗʰ THE REHEARSAL DINNER ⟵
AND OTHER EVENTS

Planning at a Glance

Just for Moms

○ Pick a location and date for the rehearsal dinner (usually hosted by parents of the groom).

○ Draw up the rehearsal dinner guest list, and send invitations 3 to 6 weeks in advance.

○ Decide if you plan to host a morning-after brunch and/or a bridesmaids' luncheon; send out invitations at least several weeks in advance.

For the Couple

○ Be sure that everyone involved in the ceremony knows the date, time, and place of the rehearsal and the rehearsal dinner.

○ If the bride and groom plan to give gifts to their attendants, these should be purchased and ready to hand out at the rehearsal dinner.

○ Determine which attendants or other guests wish to give toasts at the dinner.

The Events That Round Out an Unforgettable Wedding

While the ceremony and reception get the lion's share of attention, the other events surrounding a wedding — particularly the rehearsal dinner and the increasingly popular morning-after brunch — add to the glow of a successful wedding and to the warm memories that linger long afterward. At these celebrations, family and friends can enjoy the excitement of the event in a setting that is usually more relaxed and informal than the wedding day itself.

They're also events where the planning and hosting are likely to fall largely on the shoulders of the couple's parents. The important thing is to decide what types of celebrations you and the bride and groom envision. Talk this over together several months before the wedding, as invitations to pre- or post-wedding celebrations should go out soon after the wedding invitations. This will

help guests plan their travel itineraries—and add to their anticipation! Here are some tips on how to stay ahead of the planning curve:

The Rehearsal Dinner

The rehearsal dinner is one of the high points of most weddings. Held immediately after the rehearsal (generally the night before the wedding day), it brings together the bride and groom's families and the wedding party, and sometimes close friends from out of town. It's customary for the groom's family to host the rehearsal party—but if the groom's family chooses not to give the rehearsal dinner, it's fine for the bride's family to arrange one. Similarly, it's perfectly appropriate for the two families—and perhaps the bride and groom—to split the cost. Regardless, if the dinner is taking place in your hometown, you can be a great help by offering suggestions on possible sites.

Where to Hold It?

The venue should be reserved as soon as the dates of the wedding and the wedding rehearsal have been determined. The dinner should be held somewhere fairly close to the ceremony site. You might consider renting a room in a private club that does its own catering, or reserving a private room in a restaurant. For a small group (say, 20 or less), one large table or several tables in one area of a restaurant can fit the bill nicely. A catered dinner in a private home is also a popular option—for example, if the groom's parents are from out of town, hometown friends of the bride's family might offer their house for the dinner, with the groom's family (or whoever is paying) picking up the tab for the catering, service, and cleanup. Mainly, you want a place where people can come together, relax, and focus on what each person has to say, because the toasts and anecdotes are likely to fly!

What's the Style?

A rehearsal dinner can range from a formal or semiformal sit-down dinner or buffet to a beachside clambake or a picnic. The goal is to have a relaxed, convivial time, as everyone enjoys a chance to unwind, toast the bride and groom, and share some food, drink, and laughter before the pressures of the big day hit. The only rule: The rehearsal party should not be more formal than the wedding

reception—and preferably less so. If tuxes and suits for men are the order of the wedding day, then sports jackets and ties, or even just open-neck shirts (if the weather is warm enough) could set a perfect casual tone for the evening before.

Who's Invited?

The rehearsal dinner guest list includes the wedding party, the officiant and his or her spouse or partner, parents and grandparents of the bride and groom, and also any other siblings of the couple who are not in the wedding party. The attendants' husbands, wives, fiancé(e)s, and live-in companions should be invited, but inviting their dates is optional. At larger gatherings, aunts, uncles, nieces, and nephews of the bride and groom are frequently included as well. After that, any number of people may attend, including out-of-town guests, close friends, and godparents—*if* you want a larger group at this dinner.

Invitations are usually written on informal or fill-in cards, but they can also be written notes or even a phone call or e-mail. Send invitations three to six weeks in advance and include directions from the ceremony site to the dinner.

Who Toasts?

Toasts are made during dinner or dessert. The host—often the groom's father—makes the first toast, welcoming the guests and expressing his feelings about the forthcoming marriage. He is generally followed with a return toast by the bride's father, and then by toasts from attendants and anyone else who wishes to say

something. As a host, you (the groom's mother) can encourage close friends of the couple not to be shy about contributing to this special evening. Attendants' toasts may be sentimental, but they're also a wonderful opportunity to regale guests with tales and anecdotes from the bride and groom's past (within the bounds of good taste, of course). Sometimes the bride and groom stand and speak about each other; they generally end by proposing a toast first to their respective parents and then to all their friends and relatives in attendance.

Record the date, time, and location of the rehearsal dinner in your Address Book (page 136). Keep track of the guest list with the "Party Guest List" worksheet (page 120) and expenses with the "Rehearsal Dinner Cost Breakdown" worksheet (page 129).

An After-Wedding Brunch

The ceremony was beautiful, the reception went off without a hitch, and the party continued into the wee hours back at the hotel. When guests wake up the next morning, what more fitting capstone could there be to the perfect wedding than a delicious, casual brunch?

These increasingly popular get-togethers are a great way to have one more visit with guests who have traveled from afar before they head home. An optional event, a morning-after party is generally hosted either by the bride's parents, the groom's parents, or a close friend, typically at a private home or restaurant. They're almost always determinedly casual—open to anyone who attended the wedding and has stayed on overnight, with a flexible starting time (allowing people to wander in late or leave early to catch a plane, etc.) and an easy-going menu, often served buffet style. Invitations can be casual, as well: They can take the form of notes, phone calls, or e-mails, extended several months to several weeks or days in advance—even on the day of the wedding. Make it clear to any guests who (for some reason) didn't get an "official" invitation that they're very welcome to attend.

Record the date, time, and location of the after-wedding brunch in your Address Book (page 136). Keep track of the guest list with the "Party Guest List" worksheet (page 120).

must we invite all out~of~town guests to the rehearsal dinner?

Q: My son and his fiancée claim that all of the out-of-town wedding guests must be invited to the rehearsal dinner. Is this true?

A: It's a myth that every out-of-town guest should be invited to the rehearsal dinner. Of course, you may if you wish—but it's totally optional to do so. It often works best to keep the rehearsal dinner intimate. One thoughtful touch: Provide out-of-town guests in advance with names and phone numbers of area restaurants, so they can select a place to dine that evening.

A Bridesmaids' Luncheon

Sometimes, the bride and her mother will host a luncheon or tea for the bridesmaids and honor attendant, as an enjoyable respite in the midst of a busy time — and as a thank-you. In some communities, it's customary instead for the bridesmaids and honor attendant to host a "farewell" party for the bride.

If and when the date, time, and location of the bridesmaids' luncheon have been determined, enter this information in your Address Book (page 136). Keep track of the guest list using the "Party Guest List" worksheet (page 120).

Bachelor/Bachelorette Party

Traditionally held the night before the wedding day, nowadays bachelor and bachelorette parties are much more likely to occur during the final weeks before the wedding, often in the form of a casual "farewell" dinner or get-together, usually hosted by attendants and close friends and held in a restaurant or in a club. The bachelor party may be hosted by the groom, his father, or his best man and the groomsmen/ushers. The bachelorette party may be hosted by the bride, her mother, or her honor attendant and bridesmaids.

Record the date, time, and location of the bachelor and/or bachelorette party in your Address Book (page 136). Keep track of the guest lists with the "Party Guest List" worksheet (page 120).

A Belated Reception

If the wedding is small, the couple—or you—may decide to throw a party after the wedding to share their happiness with friends. This sort of "belated reception" typically occurs in the weeks immediately following the ceremony. It can be as formal or as informal as the couple likes: Some feature a sit-down meal and even a wedding cake, but the celebration can also be a cocktail party or barbecue. No gifts are expected—only the good wishes of those present.

Record all belated reception info in your Address Book (page 136). Keep track of the guest list with the "Party Guest List" worksheet (page 120).

~⟡ PLANNING THE RECEPTION ⟡~

Planning at a Glance

Just for Moms

- Discuss the proposed reception sites with the bride and groom before the final selection is made, to determine which best fits the requirements of the guest list, wedding style, and budget.

- Review the seating arrangements for the parents of the bride and groom and other close family members.

- Finalize reception seating, if assigned seats are desired.

- Be available to help the bride and groom with any planning details—if asked.

For the Couple

- If you're working with a wedding consultant, set aside time to review together all the aspects of planning the reception.

○ Consider including your mother(s) in some of the key reception decisions. If you do, set up a communication system for staying in touch during the planning process.

○ Select and reserve a reception site.

○ Determine with reception site manager whether you'll use the site's caterer or an outside caterer.

○ With your caterer, decide on the menu and type of food and beverage service.

○ Visit the reception site to plan the linens and place settings and locations of food and bar, tables for guests, dance floor and musicians/DJ, wedding cake display table, place card table (if needed), gift table (if needed), and receiving line.

○ Investigate parking options, site accessibility, acoustics, lighting, and room temperature controls.

○ Plan the décor and flowers with the site manager and your florist.

○ Arrange transportation from the ceremony site to the reception for the wedding party and any special guests.

○ Verify directions to the reception site; if preprinted directions aren't available, have direction cards printed for inclusion with the invitations.

○ Provide the caterer, reception site manager, and/or maitre d' with a timed schedule for all reception events; then clearly delegate responsibility for managing the event's flow.

○ Once RSVPs have been received, submit a final guest count to the caterer and/or reception site manager and finalize seating arrangements.

Selecting the Reception Site

The reception site will have a tremendous impact on how the couple's big day will be remembered. Many factors play a role in creating the "perfect" celebration: the ambience and layout of the reception area, the manner in which food and beverages are served, and the skill and demeanor of the site manager, caterer, and other service professionals. The key is to choose a site that appeals to the bride and groom, ties in well with the style and formality of the wedding, and can

comfortably accommodate the number of guests being invited. It's also important to make sure that the reception's menu, décor, and musical entertainment are all within the parameters of the wedding budget.

You may have a location in mind—a country club that is the favored wedding reception site among you and your friends or an historic mansion or gardens. Even so, the couple may have other ideas—so be sure to broach the topic of any favorite spot of yours as a suggestion, nothing more. Whatever the dreams and possibilities, it's essential to start searching for a site early. In fact, deciding on the reception site is one of the first steps to take (preferably nine to twelve months in advance—sometimes even sooner) to ensure availability. This is especially true if you're looking at popular reception locales.

It's a good idea to consider a wide variety of options when starting the search. Once the couple begins seriously to evaluate various sites, the field often narrows quickly to a few top candidates.

Important Considerations to Keep in Mind

* *The reception site should match the wedding's level of formality.* For example, a New England clambake in a rustic barn might be perfect for an intimate, casual wedding but would *not* be a wise reception choice for a formal wedding.

* Since popular sites are often booked long in advance, **have several possible wedding dates in mind** when starting the search. This will give the couple, and you, the best shot at booking the first choice of reception location.

* *Logistics and time availability* are also key factors. Ideally, the reception site is not far from the ceremony site and is available immediately after the ceremony. The goal is to avoid keeping guests waiting longer than thirty minutes between the ceremony and the reception.

* Check to see that the site has **sufficient restrooms.** If a coatroom is needed, make sure there is one; otherwise, coat racks might have to be rented. Investigate the **acoustics and lighting.** Make sure the space offers **good air circulation.** If the air flow is less than ideal (at a church hall with few windows, for example), extra fans may be needed.

- *Accessibility* is also essential. If the parking area is a substantial walk from the reception site, arrange for valet parking. If driving to the site is difficult, consider hiring minivans or even a bus to transport guests to and from the reception site. Check also on access for the disabled. A steep flight of stairs could cause real problems if some wedding guests have limited mobility.
- Finally, remind the couple that they need to be absolutely sure of their wedding date and site choice before signing on the dotted line: Most sites require a sizable deposit at the time they are reserved and have equally steep cancellation fees.

Key Things to Know About the Reception Site

- Is a wedding package offered — and if so, what does it include? Are substitutions permitted?
- Does the cost include tax and/or gratuities?
- What is the site's maximum seating and standing capacity?
- Does the site supply its own caterer, or must one be hired from elsewhere?
- Is there a fully equipped kitchen for food preparation?
- What policies and restrictions does the site have for food, beverages, music, flowers, décor?
- Does the site provide its own alcoholic beverages — and if so, can the couple substitute their own liquor if desired?
- Are there enough tables and chairs, or will additional ones have to be rented?
- How many hours will the site be available for use?
- May the reception be extended an extra hour or two — and if so, what would the overtime charges be?
- Is there a room or outdoor space for taking group photos?
- Is convenient parking available?
- Can the space accommodate the size of band or orchestra you're considering?

- How many people can be on the dance floor at one time?

- Are coat-check and valet-parking personnel provided?

To evaluate and compare different reception sites, use the "Comparison Chart" worksheet (page 123). Once the reception site has been selected, enter it in your Address Book (page 136).

Food and Beverages

One of the most important factors in choosing the reception site is whether the site has its own in-house caterer and/or bar service—and if so, are clients required to use him or her, or do they have the option of bringing in their own caterer and/or liquor supply? There are pros and cons to each approach:

- An in-house caterer saves you the trouble of finding your own caterer. Also, since they are very familiar with the facilities, there's less chance of glitches. Because they don't have to cart in food, heating trays, linens, and so on, the price may be slightly lower as well. On the other hand, your menu choices will largely be limited to the caterer's standard offerings— though many in-house caterers will try to oblige special requests, within reason.

- Bringing in your own caterer gives you much more flexibility, since you can shop for a caterer whose selections appeal to you and fit your budget. On the downside, unless your caterer has worked at this site before, he or she will be preparing and serving food in an unfamiliar setting. And since the linens and waitstaff (and possibly tables and chairs) are all being brought in, the logistics on the day of the reception will be that much more complicated.

- The same logistical concerns hold for bringing in your own liquor—but in this case, the potential savings in buying your own alcohol compared to paying the reception site's prices (which are often charged on a per-drink basis) are likely to be substantial.

the location versus food trade~off

The bride and groom think they've found the perfect reception setting; they've come to you for your input before the contract is drawn up. The only catch: The site requires that its own caterer supply the food—and from what you've sampled, it's less than great. This sort of trade-off needs to be addressed before it's too late, and you're the one to do something about it. If you're all working with a professional wedding consultant, ask his or her advice, too. One option is look for another site that lets you employ an outside caterer. If you've had previous success with a caterer, you might choose this route. Alternatively, be prepared to sit down with the site manager and in-house caterer to work out the menu in detail, including coming up with creative substitutions for dishes that you and the couple feel aren't up to par. (It may be helpful to enlist a friend or family member with experience in the food service industry to offer some suggestions.) With a little polite, well-informed encouragement, most in-house caterers will be happy to expand their repertoire—and raise the level of their performance in the process.

Key Things to Know When Hiring a Caterer

Whether you're using an in-house caterer or hiring an outside catering service, always sample a variety of offerings before signing a contract, and again before selecting a menu. Also, ask the following questions:

* What food and drink choices can be offered at the cocktail hour? During the reception?

* Are substitutions permitted?

* What styles of service are available, and what are the comparative costs?

* Is a champagne toast included?

* Is a choice of wine with dinner included? What wine and beer choices are offered?

* If the caterer is providing the liquor, what is the price difference between brand-name liquors and house brands?

- What is the price difference between an open bar just for the cocktail hour and an open bar throughout the reception?

- What is the ratio of serving staff to guests?

- Are gratuities for the staff included in the cost?

- Is there a special rate for providing food and beverages for the musicians, photographer, and videographer?

- What special rate and accommodations can be made for providing food and beverages to children?

- Are there additional fees for the rental of linens, china, flatware, crystal, tables, and chairs?

- What are the choices of table linen colors?

- What are the choices for china, silver, and crystal?

- Is insurance against china and crystal breakage included in the costs? If not, what would this additional insurance cost?

- Can the couple provide their own wedding cake — and if so, is there any extra cost for this?

- Who will be on-site during the reception to oversee the event?

- When and in what form must the final guest count be provided?

- What is the charge if the reception should run overtime?

To compare caterers, use the "Comparison Chart" worksheet (page 123). Once the caterer has been selected, enter the name and contact information in your Address Book (page 136). Keep track of food expenses on the "Reception Cost Breakdown" worksheet (page 128).

A Mom's Primer on Food Service

The choice of food service has its own impact on the feel of a reception. A seated meal tends to keep people at their tables during the main part of the reception — ensuring an attentive audience for toasts and other announcements — while other styles are more conducive to mingling. Following are the most common service choices:

Sit-Down (or "Seated") Meal

A sit-down meal is a meal at which reception guests are seated and served by waitstaff. While having additional servers means added expense, this approach lets you control portion size—so that the per-person cost may actually be less than for a buffet. This will largely depend on the choice of foods, however (lobster will cost substantially more than chicken, no matter how it's served).

Buffet Style

At a buffet, guests select foods from one long table filled with choices or from several food stations situated throughout the room. Guests either serve themselves or are served by a staff member standing behind the buffet table.

Passed-Tray Service

Passed-tray service, where waiters circulate through the room with trays of hors d'oeuvres, is typically used during the cocktail hour. It's often the prelude to a buffet or sit-down meal, or it may be augmented by a buffet table containing crudités, cheese and fruit, or more substantial fare.

The Wedding Drinks

If you serve alcohol, you'll need to figure how much to serve, the method of service, and how long to serve it. Some receptions offer champagne and wine only; others hold an open bar during the cocktail hour and serve wine, beer, and champagne during dinner; still others keep the bar open throughout the festivities. Be sure also to offer nonalcoholic beverages, including assorted sodas, iced tea, juices, coffee, tea, and bottled water.

Alcohol Cost-Cutters

* **Have a soft bar instead of a full bar.** Serving hard liquor is expensive, since it requires having a wide variety of alcoholic beverages and mixers on hand. With a soft bar, guests are typically limited to ordering champagne, beer, nonalcoholic beer, red and white wine, sodas, iced tea, juices, coffee, tea, and mineral water.
* **Buy your own liquor.** Some caterers will let you buy your own liquor— or they'll buy it and bill you at cost, plus a small percentage for labor. For additional savings, purchase house brands.

- **Have a consumption bar rather than an open bar.** If your guests are light drinkers, it may make sense to negotiate a per-drink fee. If the facility's open-bar fee is based on an average of five or six drinks per person, and you're also serving wine with dinner and champagne for toasting, the per-drink rate may save a significant amount of money, since it's highly unlikely that each guest will consume five glasses of liquor along with the wine.

Keep track of beverage expenses on the "Reception Cost Breakdown" worksheet (page 128).

The Wedding Cake

A wedding cake is a centuries-old custom that serves a number of purposes: It's typically the visual focal point of the reception, and the cutting of the cake by the bride and groom symbolizes their commitment to sharing life's journey. Even better, all the guests get to share in this symbol — while eating a delicious dessert! There's no set rule on the size or shape of the cake: It's really up to the couple and the baker.

- **Selecting a baker:** Ask the caterer and/or reception site manager for recommendations, then make appointments with candidates to review photos of their work and to discuss designs and ingredients. Always ask to taste samples of cakes, fillings, and icings *before* signing a contract.
- **When to order:** Cake orders should be placed at least six to eight weeks before the reception.
- **Bringing in a cake:** If the cake is being baked elsewhere and transported to the reception, let the site manager and caterer know when the cake is being delivered — typically several hours before the reception starts, to ensure that the cake is in place when guests enter the reception. Since multitiered cakes are usually assembled and decorated at the reception site, make sure a space is available for the baker to work in.
- **Displaying the cake:** The cake may be placed on the bridal party table or at the center of a buffet table, but more often it's displayed on a small table or cart of its own. Sometimes the cake is hidden until the cake-cutting, and the music stops as it's wheeled into the dining room.
- **Cutting the cake:** This event takes place at the end of the entrée course, just before dessert and coffee are served. Make sure the caterer,

photographer, and videographer are all aware of when the cake will be cut. In the cake-cutting, the bride puts her hand on the knife handle and the groom puts his hand over hers. They carefully make two cuts to make a small piece, which is then placed on a waiting plate with two forks. The groom gently feeds the bride the first bite, she feeds him the second, and the couple then kisses. The cake is then taken away and cut into slices to be served to the guests.

✽ **Saving the top layer:** Couples often save the top layer of the cake, to be frozen and eaten on their first anniversary. If the bride and groom wish to do this, be sure to tell the caterer in advance.

To compare bakers, use the "Comparison Chart" worksheet (page 123). Once a baker has been selected, enter the name and contact information in your Address Book (page 136).

Places, Please: Seating Arrangements

The wedding party's table is usually set against one side or at one end of the room. If the table is rectangular, the bride and groom are seated at the center of the table facing out, the bride to the right of the groom, with no one seated across from them. The honor attendant sits on the groom's left, the best man on the bride's right, and the rest of the bridesmaids and ushers alternate along the same side of the table. If the group is very large — or if the attendants' significant others are joining them at the table, which is usually the case — a U-shaped table (with the bride and groom seated at the bend of the U) or two round tables (with the bride and groom joined by the maid of honor and best man and their respective partners) may be used instead.

As for assigned parents' tables, this is really up to you, the bride and groom, the other parents, and the nature of the venue. Even if the reception guests aren't going to have assigned seating, it's often customary to set aside separate parents' tables for the bride's immediate family (parents, grandparents, and other close relatives) and for the groom's immediate family — typically alongside the table where the wedding party is seated. It's fine if both sets of parents want to sit together, but this is often impractical, since each set generally comes with its own entourage of extended family and friends.

It's traditionally up to the bride and groom to decide if they want to give assigned seats to other guests. For a seated reception or formal buffet, seating assignments are customary but not required. If the couple opts for assigned seating, this is a perfect time for you, the mother of the bride or groom, to weigh in, since you'll have great input to offer regarding possible seating arrangements. Some tips to keep in mind:

- Think about who might enjoy conversing with each other, whether they're acquainted or not. Employ some tact, consideration, and a sense of fun to create combinations that have potential for an especially enjoyable time.

- Request a diagram of the table setup from the reception site manager before deciding on seating arrangements.

- As RSVPs come in, write the names of attending guests on cards. Arranging and rearranging the cards into table groupings is an excellent visual means of figuring out good combinations.

- If place cards are used, delegate to someone the task of alphabetizing and delivering the cards to the reception site before the ceremony.

- Rather than placing the groom's and bride's friends and family on opposite sides of the room, intersperse tables to encourage mixing.

- Avoid seating one stranger at a table where the rest of the guests are close friends.

- Seat guests who are disabled near the entrance and/or restrooms, and those with impaired sight or hearing near the bridal table. Avoid seating the hard-of-hearing right next to the band.

MOTHER'S ETIQUETTE ALERT

where should divorced parents sit?

If the bride's and/or groom's parents are divorced, they will likely prefer to be seated at separate tables, even if their relationship is amicable. This gives each parent his or her own space to celebrate with extended family and friends. If all the parents really do get along well and want to sit at the same table, however—and it's fine with the bride and groom—then by all means they should feel free to do so.

is a receiving line required?

Q: *My daughter and her fiancé don't want a receiving line. She tells me they prefer to let the guests head directly to the reception, and that a receiving line is optional. I always thought that this was an essential part of a proper wedding. Who is right?*

A: Your daughter is correct: Receiving lines are definitely optional. What *is* essential is for the bride and groom to greet and thank each guest. A receiving line is an effective way to ensure this, especially if the wedding is a large one.

If your daughter and her fiancé do choose to have a receiving line, it should be held either at the ceremony site immediately following the service or as soon as the couple reaches the reception site. To avoid leaving guests hanging, arrange for formal photos to be taken after the receiving line is finished or, if they're taken beforehand, make sure the photo session is carefully organized so that it takes up as little time as possible.

A receiving line typically includes the bride and groom, their parents, and the bride's attendants. If the wedding party is small, the groom's attendants may join the line. Ideally, the line should be located where guests can partake in refreshments while waiting their turn. It's a nice touch to position a waiter at the end of the line with a tray of champagne or other beverages. There should also be a small table nearby, where guests can place their drinks while going through the line.

Place Cards

If the reception involves planned seating for more than twenty guests, place cards are strongly recommended. Blank cards can be ordered along with the wedding invitations or purchased separately at a stationery store. They should be filled in by one person, with the names of each guest either written or calligraphed. They can also be created on a computer, using a font that resembles calligraphy. Each guest's name is printed on one-half of a letter-sized sheet of paper, which is most often folded over.

For a small reception with just a few tables, the cards can be placed at the seat of each guest. For a larger reception with numbered tables, the place cards should include table numbers and all cards should be placed alphabetically on a side table near the reception entrance, where guests can pick them up after going through the receiving line. Each table then gets its own numbered card, so guests will know which table is theirs.

For more casual receptions, place cards may be used only for the bride and groom, their attendants plus spouses and guests, and parents' tables, leaving other guests to sit wherever they like. At some receptions with partial assigned seating, special guests—such as grandparents and other seniors, as well as the wedding officiant and spouse or partner—are also directed to reserved tables.

Getting to the Reception

If you plan to hire limousines, begin looking for a reputable company the minute your ceremony and reception sites are confirmed, since rented limos are in high demand at peak times. Don't try to cram the entire wedding party in with the bride and groom on the way to the reception (see "Stress-Busting Tip," next page). Figure on hiring at least three limos: one to carry the bride and her father to the ceremony and the bride and groom to the reception; a second car for the bride's mother (or both parents) and any children in the wedding party, plus any attendants who plan to ride with the bride's mother and father to the reception; and a third car for the rest of the bride's attendants. If the sky's the limit and you want to hire additional cars for special guests, grandmothers, or whoever, that's fine, too.

Before signing the contract with the limo company, drive the route from the ceremony site to the reception site at the same hour and day of the week as the wedding, to get the timing down. This way, you can give the car service an accurate estimate of the hours you'll need them. (Don't forget to allow time for traffic tie-ups.)

To evaluate and compare car services, use the "Comparison Chart" worksheet (page 123). Once a car service has been selected, enter the name and contact information in your Address Book (page 136). Keep track of car service expenses with the "Transportation Cost Breakdown" worksheet (page 135).

savoring a special moment

As the mother of the bride, your ride to the ceremony is an experience to be savored—so double-check that the limo will be ready and waiting in plenty of time for you to embark from wherever you're dressing for the occasion. And even if the trip from the ceremony to the reception takes just a few minutes and the hired cars are huge stretch limos, suggest strongly to the bride and groom that they enjoy the luxury and romance of making the drive alone with each other. This will very likely be the first time they've been alone all day and will probably be the last time they'll be alone until they leave the reception. Encourage them to spend this special moment together—the memory of which will last a lifetime.

Once total reception expenses (including food, beverages, and transportation) have been determined, enter them in the "Reception Cost Breakdown" worksheet (page 128) and the "Master Wedding Budget" worksheet (page 124).

added touches

~⁓ THE BEAUTY OF FLOWERS ⁓~

Planning at a Glance

Just for Moms

○ Assist the bride and groom in selecting floral arrangements for the ceremony and reception.

○ Make sure your corsage and the corsages of other family members match your wedding attire.

For the Couple

○ Choose a florist and begin making floral selections.

○ Finalize floral plans and ask the florist for an itemized cost breakdown.

○ Provide the florist with contact information for the ceremony and reception sites.

○ Set up a delivery schedule and confirm with the site manager.

○ Make arrangements to rent or borrow large plants or ferns (if desired).

○ Call the florist for a final check to reconfirm selections and delivery times.

Wedding Blooms

The bouquets carried by the bride and her attendants; the blooms that adorn the lapels of the groom, groomsmen, and ushers and the outfits of mothers and other important female relatives; and the sprays of flowers decorating the ceremonial vestibule and the reception tables all contribute to the romance and ambience of an unforgettable wedding. This is an area where a mother's touch and wisdom

can be extremely helpful. Successful planning here means balancing the overall color scheme and style of the wedding with the smallest details, such as choosing corsages that complement the outfits of key participants (including yourself!) without being overly ornate or difficult to wear.

A Wedding Flowers Checklist

The first step is to draw up a list of exactly what flowers will be needed for the ceremony and the reception. The following is a *general* guide to the possible ways flowers can be employed at a wedding; it's intended simply to provide a starting point as you and the couple begin working with the florist.

The Bride and Her Attendants

○ Bride's bouquet and flowers for hair

○ Honor attendant's bouquet and flowers for hair

○ Bridesmaids' bouquets and flowers for hair

○ Flower girl's basket of petals and flowers for hair

○ Tossing bouquet

The Groom and His Attendants

○ Groom's boutonniere

○ Best man's boutonniere

○ Groomsmen's/ushers' boutonnieres

○ Ring bearer's boutonniere

Family Flowers

○ Corsage for mother/stepmother of the bride

○ Corsage for mother/stepmother of the groom

○ Grandmothers' corsages

○ Boutonniere for father/stepfather of the bride

○ Boutonniere for father/stepfather of the groom

○ Grandfathers' boutonnieres

Flowers for the Ceremony

- ⭕ Entranceway
- ⭕ Altar or *chuppah*
- ⭕ Pews
- ⭕ Candles
- ⭕ Roses for parents (if desired)
- ⭕ Aisle runner

Flowers for the Reception

- ⭕ Table centerpieces
- ⭕ Buffet table
- ⭕ Head table
- ⭕ Place card table
- ⭕ Cake table, cake-topper, cake knife
- ⭕ Mantels, stairways, and entranceways
- ⭕ Garnish for serving platters
- ⭕ Restroom
- ⭕ Flower petals for tossing

Gift Flowers

- ⭕ Party hosts
- ⭕ Out-of-town guests
- ⭕ Weekend hosts
- ⭕ Thank-yous to friends and helpers

Selecting a Florist

Many reception sites and/or caterers will have a "short list" of florists whom they've worked with in the past. Selecting a florist familiar with the reception site has advantages: He or she will have a sense of what types of arrangements

work best in this location and will already have an established relationship with the site's manager and a knowledge of the facilities—helping to ensure a smooth delivery and installation on the wedding day.

It's imperative that the florist be willing to visit the ceremony and reception sites ahead of time, in addition to carefully reviewing the wardrobes of the wedding participants.

Key Things to Know When Choosing a Florist

Before selecting a florist, it's essential that you review his or her album or portfolio of previous weddings and also discuss in general terms what your vision is and what the florist's suggestions are on how best to achieve the look you're after. Compatibility is essential: In your first meeting, there's nothing wrong with saying that you aren't ready to sign a contract but are looking for someone with whom you can work. Other important points to cover:

- Does the florist seem like someone who will be enjoyable to work with?

- Does the florist offer wedding packages—and if so, what do they cover?

- Can the florist provide an itemized breakdown of prices before the contract is signed? (This is a must—if not, this florist isn't for you.)

- Are delivery and installation included in the contract?

- Are gratuities included in the contract?

- Will the florist be personally involved with the wedding-day details and distributions? If not, how will the flowers be delivered, and by whom? Also, who will be responsible for distributing and fitting boutonnieres and corsages?

- Can the florist meet with the caterer and cake baker to ensure a complementary overall décor?

- Does the contract specify guarantees on freshness and quality?

To evaluate and compare different florists, use the "Comparison Chart" worksheet (page 123). Once the florist has been selected, enter the name and contact information in your Address Book (page 136). To keep track of floral expenses, use the "Flowers Cost Breakdown" worksheet (page 130).

Before Getting Started

Before making any floral plans, discuss with the ceremony and reception site managers whether these sites have any restrictions on décor. Getting clearance to install decorations is imperative. It would be a tremendous disappointment, not to mention a colossal waste of time and effort, to finalize your plans and then find out flowers aren't allowed at the site. Questions to ask include the following:

- Are there any decorating restrictions or rules?

- At what time may decorations be delivered, and how will access be arranged?

- Does the ceremony site provide an aisle runner, should you want to use one, or do you need to order one from the florist?

- Are centerpieces and other decorations included in the contract, or do you have to provide your own flowers and decorations? If the former, may you exclude these from the contract and use your own florist?

- What, if any, decorations will already be in place?

- May flowers be taken by guests after the reception? (The answer should be yes, unless you are using the facility's own containers or have other plans for the flowers.)

Working with the Florist

The more prepared you and the couple are when meeting with the florist, the more productive these sit-downs will be. You should come armed with

1. **A complete list** of your estimated floral needs and desires, from personal (those carried, worn, or given as gifts) to ceremony and reception site arrangements

2. **Photos or sketches** of the bride's gown, attendants' gowns, and any headgear

3. **Swatches** of the bride's gown, attendants' gowns, and, if possible, table linens at the reception. This is an excellent way to match fabrics with complementing flowers. Also, if they're available, bring swatches or reference colors of the dresses to be worn by mothers, grandmothers, or any other special people who will be wearing corsages. If these dresses haven't been selected yet, color information can be delivered, phoned, or faxed later.

4. **Head circumferences** of the bride and any of the attendants who will be wearing flowers in their hair. You'll also need to ask the best way to attach flowers to chignons, twists, or other hairstyles.

5. **Height and approximate weight** of the attendants, so that bouquets will be neither too big or too small
6. **Sketches or photographs** of the groom's, groomsmen's, and ushers' attire
7. **Other photographs** of decorations or color schemes you particularly like

The Joy of Corsages

It's traditional to give corsages to the mothers of the bride and groom. But don't forget that all grandmothers in attendance should also be presented with a corsage. An additional meaningful touch: giving corsages to any other older females who are especially close, such as aunts, great-aunts, and godmothers. There's also no reason to take a cookie-cutter approach to corsages. Don't be shy about making your own preferences known, if asked. In addition, the couple might inquire what other women receiving corsages will be wearing, as well as their personal preferences and styles. A good florist will work with you to customize corsages to individual wardrobes and tastes.

Finally, a corsage doesn't necessarily have to be pinned to each woman's outfit. If this might be awkward or difficult, either because of the woman's attire, her age, or the delicacy of the fabric of her outfit, a wrist corsage is a lovely and perfectly appropriate alternative.

~⚘ There's Music in the Air ⚘~

Planning at a Glance

Just for Moms

○ Discuss what type of music the couple is considering for the reception and give input—**if** they would like some ideas—to help guide a choice that will maximize the enjoyment of all the guests.

○ Be thinking of what songs you might like for special dances with the groom, your husband, and so forth.

○ Review musical selections for the ceremony with the couple.

For the Couple

○ Find out whether the ceremony site and reception site have any restrictions regarding music.

○ Determine the basic music needs and preferences for the reception. Decide if you want a DJ or band—and if so, what kind of band. Consider your budget, the available space, the mood you want to create, and the age range and tastes of your guests.

○ Interview candidates and listen to their demo recordings.

○ Book musicians and have them sign a written contract specifying the services they'll provide.

○ With the bandleader or DJ, go over your reception playlist, your "please don't play" list, announcement needs, and special requests.

○ Review details of the band setup with the reception site manager and ask the musicians to visit the site before the wedding if possible, to familiarize themselves with the layout and identify any potential problems.

○ Meet with the officiant or the music director at the ceremony site to decide which songs and hymns will be performed during the ceremony.

○ If a ceremony program is being printed, include the names of musicians and all musical selections.

○ Call all contracted musicians several weeks before the wedding to reconfirm date, time, and addresses and discuss any remaining details.

The Goal: A Great Time for One and All

Every couple wants the perfect band for their friends to dance to at the reception. Your role, as mom and adviser, is to help them stay mindful of the fact that the perfect band is one that plays a mix of great dance music that young and old will all love. A group that also plays big-band or swing music, for instance (or a DJ with a collection of recordings that span the decades) will have the older generation on the dance floor, too—while younger wedding guests will surely be dancing up a storm as well. Here's an ideal time for your sensible, calm input, helping the couple opt for a variety of music that will be pleasing to everyone attending the wedding.

Before Getting Started

First touch base with the reception site manager, to find out whether the site has any restrictions regarding amplified music or large bands. Also, the couple (or you) should take a hard look at the dimensions of the reception site and its sound system (if any) and electrical supply, to help determine what type and size of band will work best there. Ask the manager to point out exactly where the band or DJ will be located in relation to the dance floor and how this will affect the layout of the tables. (A very large band could mean less seating for guests.) Finally, does the reception site have a piano or stage available for possible use?

Let Us Entertain You

Often, the best way to find wedding entertainers is through word of mouth. Start by asking friends and families for the names of any great wedding bands or DJs they've hired themselves or heard at other people's receptions. Your reception site contact may have recommendations as well. Other good sources: local caterers, florists, bridal shops, and musicians unions, as well as the Internet. Many wedding bands and DJs now have their own Web sites; there are also a number of Web sites that feature contact information for wedding bands around the country, indexed by state.

Besides playing the type of music the couple desires, the other key attribute to look for is *plenty of wedding experience*. An experienced entertainer will have a large, wedding-tested repertoire; be willing and able to add new songs if asked;

know how to pace themselves; and be prepared to handle key moments—such as the first dance of the bride and groom, the best man's toast, the cutting of the cake, and the tossing of the bouquet—with ease and assurance.

ADVISER TO THE BRIDE AND GROOM

live band or DJ?

The first question facing the bride and groom is whether to go with a live band or hire a DJ to play recorded music. Each approach has its advantages:

• A live band provides an immediacy and energy that will contribute to a truly memorable wedding. It can literally set the tone for the entire event. Perhaps it's irresistible rock and roll, a classic big band with a full, lush sound that will transport the reception hall, or a polka band—very popular in some parts of the United States—guaranteed to bring entire groups of friends and family together on the dance floor.

• With a DJ, what you get is maximum flexibility: A good DJ has thousands of recordings at his or her fingertips; virtually any request for a popular song can be fulfilled instantly. A good DJ is also knows exactly which recordings are sure to get everyone on their feet—and stay there—and can shift the mood of the party in an instant. If the reception runs overtime, a DJ can easily continue to spin platters. Finally, a DJ tends to cost only half as much as a typical band.

Stop, Look, and Listen

Before signing a contract with any band or DJ, the couple should always ask for a demo audio recording or videotape of a performance—preferably at a previous wedding—that they can take home and review. (Some bands make this even easier by posting videos of their performances online.)

Key Things to Know Before Choosing Music for the Celebration

Once the couple finds a demo they like, they should interview the DJ or band-leader, either face-to-face or over the phone, to ask the following:

For a DJ

* How extensive and varied is his or her recording collection, and how many recordings will be on hand at the wedding?

For a Band

* What is the size of the band, and what kind of instruments and equipment do they use?

* What kind of music do they specialize in?

* Can they learn new songs, if asked to?

For a Band or DJ

* How much experience do they have playing at weddings?

* What does a typical playlist look like?

* Are they willing to play special requests?

* How do they like to handle special moments such as the first dance of the bride and groom and the cutting of the cake?

* How many breaks do they take, and for how long?

* How much space do they need to set up in?

* Can they visit the reception site prior to the wedding date?

* What will they be wearing?

* What is their rate (including overtime charges), payment schedule, and cancellation policy?

To evaluate and compare different bands or DJs, use the "Comparison Chart" worksheet (page 123). Once the musical entertainment has been selected, enter the name and contact information in your Address Book (page 136). Keep track of music expenses with the "Music Cost Breakdown" worksheet (page 133).

the loudness factor

If the band or DJ is partial to rock and roll and your guest list includes a number of people you know won't appreciate (or may have trouble hearing over) extremely loud music, discuss your concerns with the bride and groom a few weeks before the wedding day. Either the couple (or you) can then arrange with the bandleader or DJ for a musical program that begins on the quieter side for the first hour or so, while everyone is eating and conversing, then builds in volume later.

Striking the Right Note: Music for the Ceremony

The right musical touches can set the perfect mood and express heartfelt emotions—which is the essence of a moving wedding ceremony. Most ceremonies enlist one musician—typically an organist or keyboardist, though a harp, flutist, trumpet player, or string ensemble are also popular—to play during the prelude, the processional, the recessional, the postlude, and other interludes during the service. Many couples embellish the ceremony by enlisting singers and/or instrumentalists (often good friends or family) to sing or play songs of special meaning during the service, or by selecting favorite hymns for everyone to sing.

It's essential that the couple first talk with the officiant or ceremony site manager to find out what musical restrictions (if any) the site has. Some houses of worship, for example, prohibit the playing of amplified and/or secular (non-religious) music. Other sites may require you to use their musical director and/or in-house singers or musicians.

The last step is to finalize the actual music for the ceremony, including the prelude, processional, and recessional. The couple will need to decide where in the service they'd like to add vocal or instrumental solos, and what songs they'd like to have performed. If the service is going to include hymns, the couple should also draw up a list of hymns that hold special meaning for them.

Choosing the Musicians

If the ceremony site doesn't have its own organist or keyboardist or vocalist, one possible solution is to ask the reception band's keyboardist (assuming it has one) and/or vocalist if he or she could play for the ceremony (many wedding pros will even offer to do this as part of the band package). Alternatively, ask family, friends, and other contacts for personal recommendations (see "Let Us Entertain You," page 95).

To evaluate and compare vocalists or musicians for the ceremony, use the "Comparison Chart" worksheet (page 123). If and when the ceremony performers have been selected, enter their names and contact information in your Address Book (page 136). Keep track of ceremony music expenses on the "Music Cost Breakdown" worksheet (page 133).

Key Musical Moments in the Ceremony

- The prelude (reflective background music that's played for about 30 minutes prior to the ceremony's start)

- The processional (joyous, dramatic music played at a slow tempo as the wedding attendants walk down the aisle; the bride, last down the aisle, may walk to the same music as the rest of the procession or to different music, played at a higher volume)

- Interludes (moments of reflection during communion, between readings, and so on — good points for a vocal or instrumental soloist to perform)

- The recessional (triumphant, majestic music with a quick tempo)

- The postlude (joyous, fast-paced music played as the guests depart)

your turn in the spotlight

The traditional first dance between the bride and groom is a magical highlight, and the couple should think carefully about what song they'd like to have played at this special moment. The second dance is also special, for this is when the bride traditionally dances with her father. Midway through the song, they may be joined on the dance floor by the groom and his mother—though in some cases this latter pair may dance separately to a third song. The parents of the bride and groom may also dance with their husband or wife at this time. If you have a special request for your moment in the spotlight, pass it along to the couple and their music leader a month or so before the big event. ("If you haven't picked a song for the second dance, there's one I'd love them to play...") The couple will likely be more than happy to accommodate your request, and this will give the band time to rehearse it, if necessary.

You might also encourage the bride and groom to compile a list of any songs that they'd especially like to have played during the reception—as well as what songs (if any) they'd prefer not to have played—and what type of music they'd like during the following key moments:

- The entrance of the bride and groom
- The bride and groom's first dance
* The bride's dance with her father
- The groom's dance with his mother
- The best man's toast
- The cutting of the cake
- The bouquet toss and garter toss
- Special dedications
- Last song

~𝕀⊚ Pictures to Last a Lifetime ⊚𝕀~

Planning at a Glance

Just for Moms

○ Draw up a list of your must-have shots (groups, individuals, and moments) to pass on to the couple to give to the photographer and videographer before the wedding day.

○ Help delegate someone to point out key individuals to the photographer and videographer at the reception.

○ Be ready to pitch in, if necessary: You might occasionally help identify must-have photo and video opportunities on the wedding day.

For the Couple

○ Determine the budget for photography and videography.

○ Meet potential photographers and videographers and review samples of their work.

○ Once a photographer and videographer have been selected, sign written contracts specifying all services and costs.

○ Give both the photographer and videographer a list of must-have images.

○ Arrange to have any studio portraits taken before the wedding date.

○ Establish a timetable for formal group photos.

○ Ask a good friend who's attending the wedding to point out key friends and family members to the photographer and videographer at the ceremony and reception. Your mothers can be helpful, too, in guiding the photographer toward must-have photos and videos.

○ Call the photographer and videographer a week before the wedding to confirm locations and starting times.

○ After the big day, review proofs and unedited videotape and select images for the photo album and edited video.

Worth a Thousand Words...

The wedding photos and/or video will be shared and reminisced over for the rest of your lives—so these are jobs that need to be meticulously prepared for and masterfully executed. As the mother of the bride or groom, you can help make sure this happens by keeping the focus on three key areas: hiring the right photographer and videographer, making absolutely sure they get the desired photos and video footage, and having input into the actual production process of the photos and video.

Picking the Right Photographer and Videographer

After gathering names of several promising candidates by canvassing the usual sources (friends and family, the reception site manager, other wedding service providers, the phone book, and the Internet), the couple needs to carefully review the candidates' recent portfolios for style, technique, and content.

The ideal photographer needs to be expert at snapping those large, formal group photos that will be gracing walls and mantels for decades to come; but these days the best wedding photographers also bring a journalistic sensibility to the table—showing up early to capture the excitement of the bride and her attendants making their preparations, being an unobtrusive presence at the ceremony (if photography is allowed at the site), and roaming the reception to snap key moments (like the cutting of the cake), posed photos of tables and other groupings, and candids of guests making merry.

What to look for in a photographer's work: consistently well-focused and well-composed photos, diverse subject matter, and a fun, creative sensibility. The photos should also be attractively mounted. Note: Many wedding photographers employ an assistant to snap additional photos of the event. If so, be sure to ask to see his or her portfolio as well.

When reviewing videographers' sample tapes, you and the couple should be seeking many of the same attributes noted above, plus a clear, well-modulated audio track, especially for important moments such as the reciting of the vows (which may require one or more cordless microphones), and a good final editing job. The edited DVD should flow smoothly from one memorable scene to the next, while capturing all the key moments and emotions. The traditional, long

version (typically 30 to 60 minutes) video covers the major elements of the day, including the bride and her attendants getting prepared, the groom and his attendants gathering for the ceremony, the ceremony itself, and extended coverage of the reception. Many videographers also include a shorter edit, typically about 10 minutes long, containing just the wedding highlights. (Some couples even send these short versions out with their thank-you notes.)

Pin down exactly who will be editing the video and what the final product will include. Also, ask if it's possible for the couple (or you) to see the unedited video clips before the editing process commences.

Key Things to Know When Hiring a Photographer and Videographer

- Are they familiar with the ceremony and reception sites, and if not, can they visit the sites prior to the wedding day?
- Do they work with an assistant, and if so, what are the assistant's responsibilities?
- Will they supply all necessary equipment?
- How many photos or minutes of video do they plan to take?
- What is their rate (including overtime fees) and payment schedule?
- How will they be dressed?
- Will the couple and you be able to review the photo proofs and/or uncut video before final processing?
- Can the couple keep the negatives of all photos?
- When can the couple expect to receive the finished product?
- Is there a package discount for extra photos and/or videos for parents and other relatives?
- What is the cancellation policy?

Once a photographer and/or videographer has been selected, a formal contract should be drawn up, specifying exactly what services will be provided and what the cost will be.

To evaluate and compare photographers and videographers, use the "Comparison Chart" worksheet (page 123). When the photographer and/or videographer have been selected, enter their names and contact information in your Address Book (page 136). Keep track of photo and video expenses with the "Photography Cost Breakdown" worksheet (page 134) and the "Videography Cost Breakdown" worksheet (page 135).

Before Getting Started

It's essential to check in advance with the ceremony and site managers to see if they have any restrictions on the use of cameras, flash photography, special lighting, and equipment such as tripods. Houses of worship, in particular, may not allow the use of a flash or may forbid photography during the ceremony. If so, the photographer may have to re-create certain ceremony photographs after the ceremony is concluded.

Note: Be sure to keep the process moving quickly if many photos are to be taken right after the ceremony and before the reception. Some guests have complained of waits of over an hour for the couple to arrive at the reception.

Finally, find out when the photographer can come in and set up equipment and who his or her contact person at the site will be.

Must-Have Photos and Video Clips

Both the couple and you should take some time before the wedding to draw up lists of must-have images—including formal group photos, key moments during the ceremony and reception, and individual guests and members of the party you want to be sure to get on photos or video. For planned events such as the cake cutting, ask an attendant, a close friend, or the site manager to alert the photographer and/or videographer ahead of time as to where these events will be taking place, so he or she can be thinking in advance about how best to take the picture.

group photos with divorced parents

For formal group photos, if either the bride's or the groom's parents are divorced, it's not appropriate to ask both parents to flank the couple in a semblance of a united family. Arrange for portraits to be taken of the couple with each parent (and spouse or partner) individually.

Controlling the Final Product

Wedding photographers traditionally give their clients proof sheets shortly after the wedding, allowing the bride and groom to pick the shots they'd like to have printed. (Some have Web sites that allow this selection to be done online.) Arranging the selection process as part of the contract is essential. Similarly, arrangements should be made with the videographer to review the unedited video—or at least a rough cut—before a final edit is made. This is the time to go over any proposed titles, voice-overs, and musical overdubs. The couple shouldn't be shy about letting their wishes be known—remember, a large portion of the wedding budget is going toward getting exactly the photos and video that they (and you) want!

COUNTING DOWN
THE FINAL WEEKS

Planning at a Glance

Just for Moms

○ *Confirm with couple the start times of all wedding-related events.*

○ *Review the schedule for the rehearsal, rehearsal dinner, ceremony, and reception.*

○ *Offer to help confirm arrangements with vendors and site managers.*

○ *Confirm hairdresser and manicurist appointments.*

○ *Be available to answer any questions that relatives and friends may have, especially those who will be traveling to the wedding.*

○ *Offer to help the bride and groom with any last-minute confirmations and planning.*

For the Couple

○ *Compose the newspaper announcement, choose the portrait you want to accompany it, and mail to selected publications.*

○ *Check with attendants to make sure any last-minute fittings have been done and accessory purchases have been made.*

○ *Mail or e-mail a detailed schedule of events to your attendants.*

○ *Pick up wedding rings and check for fit and inscriptions. Put them away for safekeeping.*

○ Obtain marriage license.

○ Finalize and wrap bride's and groom's gifts to others.

○ Call, or delegate to someone to call, all wedding professionals and vendors— caterer, baker, florist, makeup artist, photographer, videographer, musical entertainment, and limousine company—to reconfirm arrangements and timing.

○ Give your completed music request list to the band or DJ.

○ Give your list of must-have photos and video clips to the photographer and videographer, if you haven't already.

○ Confirm hairdresser and any manicurist and makeup-artist appointments.

○ Double-check accommodation reservations and other arrangements for out-of-town guests.

○ Pick up ceremony programs from the printer.

○ Make a final guest list count to give to the caterer or reception site manager.

○ Finalize seating plans.

○ Fine-tune the timing for cocktails, toasts, dancing, food, beverages, and cutting the cake with caterer and reception site manager.

○ Reconfirm honeymoon reservations, and make sure you have passports or visas in hand (if needed).

○ Compose wedding announcements (if any are being sent), and arrange for them to be mailed soon after the wedding—preferably the day after.

The Best-Laid Plans...

Even with the most careful planning, miscommunication can sometimes occur. The last thing you want is for the photographer to arrive at the wrong time, the florist to be short on bouquets, or the limousines to show up at the wrong address. That's why it's essential to communicate by phone or e-mail with each service person involved in the wedding at some point during the last couple of weeks before the big day. These conversations should include

❀ The date of the wedding (this may seem obvious, but you can't be too careful!)

- The exact time and location where the service provider is due to show up

- An itemized rundown of what the vendor will be supplying

- All details about how the delivery will take place

- Any additional input you or the couple need to supply (such as a playlist for the band or DJ and the must-have photo or video list for the photographer and videographer)

- A review of the price and payment arrangements

- The dates and times of arrivals and departures of any guests staying with friends or at hotels (if you made the hotel arrangements)

As the mother of the bride (or groom), you can be a tremendous help by taking the reconfirmation process off of the couple's shoulders if they wish. Or, the reconfirmations can be made by the wedding consultant (if one has been retained), by one of the attendants, or by an organized friend or relative who has been asked to help out. Don't worry about offending any vendors and friends by going over the above points, no matter how obvious they may seem. A true professional will respect both your desire to make certain all the plans are accurate and the high value you place on their services, and will be glad to review the logistics one more time.

Details, Details

Now's the time when you and the couple need to pin down any remaining details of the rehearsal dinner (see "The Rehearsal Dinner," page 70), the ceremony (see "Planning the Ceremony," page 55), and the reception (see "Planning the Reception," page 74), including exactly what is supposed to happen when (see "Traditional Order of the Wedding Ceremony," page 114, and "A Sample Wedding Reception Schedule," page 115). You should have a final head count for the reception at this point, which then must be passed along to the caterer and the reception site manager. Reception seating plans should also be finalized, and place cards (if used) should be made up—tasks that you, as mother of the bride or groom, can offer to assist in. (See "Places, Please: Seating Arrangements," page 83 and "Place Cards," page 85.)

If the couple plans to have wedding programs, the contents should be finalized with the printer, and someone (perhaps you) delegated to pick up the finished programs (see "Ceremony Programs," page 60).

Finally, designate someone (perhaps yourself, but only if you have the time) to handle any last-minute questions from out-of-town guests regarding accommodations, transportation, and events.

the wedding itinerary

You and the couple need to draw up a detailed timeline of the wedding day and the days immediately before and after, to be given to each attendant and anyone else involved. As mother of the bride (or groom), you can be a lifesaver by offering to prepare this important document and either mail or e-mail copies to all members of the wedding party. It should include

- When and where the rehearsal and rehearsal dinner will take place

- Any beauty appointments that have been made for them

- The schedule on the morning of the wedding, including when and where the bridal party will be getting dressed

- When the cars will be arriving to transport the wedding party to the ceremony

- When and where planned group photos will be taken

- When the cars will be transporting the wedding party to the reception

- When a receiving line (if any) will be formed and who will be asked to participate

- Any other pre- or post-wedding parties or events that the bride's and groom's attendants are expected or invited to attend, such as a bridesmaids' luncheon, a bachelor and/or bachelorette party, or a morning-after brunch.

Preparing Announcements

* **Wedding announcements:** If the couple is sending out wedding announcements, these should be addressed and stamped in the final weeks before the wedding, and arrangements should be made for a relative or friend (another opportunity for you, as mom, to pitch in!) to put them in the mail on the day after the wedding—or shortly thereafter.

* **Newspaper announcements:** If the couple wishes to have their announcement and photo in any local newspapers, they should complete their announcement information and send it, together with the portrait of their choice, to selected publications at least three weeks ahead of time— or even earlier, for those newspapers that require a longer lead time (see "Planning Ahead: Check on Wedding Announcements Now," page 13). It's a good idea to send these packages via express mail or registered mail, to ensure that they reach their intended recipients in a timely fashion. You or the couple should also follow up with a phone call to each publication, to make sure the package was received and to confirm when the announcement will appear.

STRESS-BUSTING TIP

relax!

Last but not least, be sure to enjoy the big day! You can set the tone for your daughter or son, plus their betrothed, by not letting the stress of planning keep you from savoring this memorable time. Make it a point to take good care of yourself—and remind the couple to do the same. Some tips: *Eat right*—you need the energy; *get enough sleep*—you can cope better when you're rested; *exercise*— it's an effective release; *cope with, and let go of, the details*—be quick to delegate, and remember there's a solution for everything; remain calm during any relationship misunderstandings—apply the principles of etiquette: consideration, respect, and honesty with tact; *find beauty* in this happy time; *apply humor* to help you out; and, above all, *help the bride and groom to focus* on their special day. Now is the time to immerse yourselves in the fun and happiness of the wedding!

~❦ It's Time for the Wedding! ❦~

Planning at a Glance

Just for Moms

○ Reconfirm with the bride and groom the list (to be given to the ushers) of the people who will get special seating at the ceremony.

○ Review the overall schedule of the ceremony.

○ Review the thumbnail schedule of the reception's key events, and make copies to give to the site manager, caterer, and bandleader or DJ at the start of the reception.

○ Check in with the bride and groom to see if there are any last-minute details you can help out with, such as submitting any last-minute changes in the final guest list to the caterer and/or reception site manager or finalizing reception seating plans.

○ If you are traveling to the wedding, settle into where you'll be staying.

○ Be ready to possibly greet some of your guests arriving from out of town.

○ Make sure your clothes for the rehearsal dinner and wedding are pressed and ready to put on.

For the Couple

○ Confirm the rehearsal time with all participants.

○ If you plan to give the attendants their gifts at the rehearsal or rehearsal dinner, have them wrapped and packed to go.

○ Confirm with the wedding party when and where bridesmaids will gather on the morning of the wedding to get dressed and made up, and when and where the groom and his attendants will gather to travel to the ceremony.

○ Make sure that the head usher or ushers have the list of people to whom special seating will be given at the ceremony.

○ Make arrangements for the officiant to be paid.

○ Make sure that the best man and maid/matron of honor have the rings in their possession, and that the best man has the marriage license.

- Confirm timing of formal photos with family members and attendants.

- If you are having a guest book, ask an attendant or relative to get it to the reception (or ceremony) site and to oversee the signing process.

- Delegate to an attendant or relative the job of taking care of the wedding gown and the groom's outfit once you leave.

- Delegate one person to transport to your home any gifts brought to the reception.

- Confirm any arrangements for the disposal of flowers, especially if they are being given as gifts to sick friends.

- Organize going-away clothes or assign a relative or attendant to get them ready for you.

Delegate Those Last-Minute Details!

By now, the wedding plans should be well on track. Still, there are always last-minute items that need attending to. Because the final days are invariably hectic, you and the couple should try to delegate as many of these final tasks as possible—including those outlined in the "Planning at a Glance" section, above—to attendants, friends, or family members. They'll be glad to help out, leaving you free to welcome one and all to the celebration in calm, gracious fashion, without the stress of worrying about a dozen last-minute details.

The Wedding Rehearsal

The wedding rehearsal gives everyone an all-important opportunity to physically walk through the ceremony—a surprisingly helpful tradition, since wedding-day jitters can play tricks on even the keenest memory. It should be held as close as possible to the day of the wedding—preferably the afternoon or evening of the preceding day, followed immediately by the rehearsal dinner (just be sure to allow time for participants to travel from the ceremony site to the rehearsal dinner location).

* The bride and groom

* The attendants

* The bride's parents

* The groom's parents, if they have an active part in the ceremony. (If not, they needn't be present but may be invited by the bride to attend as observers—although if they're also hosting the rehearsal dinner, they may choose to leave the rehearsal early, to be on hand to greet people as they arrive at the dinner.)

* The officiant

* The organist or musician playing the processional and recessional, as well as any soloists or other participating musicians.

* Anyone else who is doing a reading or contributing in some specific way.

* The wedding consultant, if there is one, should also be on hand to help instruct the ushers, line up the wedding party correctly, and help with the spacing and pace of each person practicing walking up the aisle.

STRESS-BUSTING TIP

keeping the happy couple fresh and glowing

To ensure that the bride and groom look and feel their best on their wedding day, encourage them to get plenty of sleep the night before by retiring at a reasonable hour—even if their friends are intent on continuing the rehearsal-dinner festivities at a local night spot. For an extra-refreshing treat, offer to treat the couple to massages on the morning of the wedding.

On the wedding day itself, you can be a lifesaver by putting together a small freshen-up kit for yourself, the bride and groom, and anyone else who might need it. Things to consider including in the kit: makeup, a hairbrush and comb, hair spray and hairpins, toothpaste and a couple of spare toothbrushes, safety pins, tissues, deodorant, aspirin, a small mirror, and a sewing kit for emergency tears or fallen hemlines.

Traditional Order of the Wedding Ceremony

Following is the traditional sequence of events for the wedding ceremony. Of course, there are many variations, but this will provide a good reference as to the general progression:

1. One hour before the ceremony, the ushers arrive.
2. As guests arrive, the ushers welcome them and escort them to their seats as prelude music is played.
3. Grandparents and other honored guests are escorted to their seats.
4. The parents of the groom are escorted to their seats.
5. You—the mother of the bride—are ushered to your seat.
6. The aisle runner, if used, is rolled out by the ushers.
7. The processional music begins.
8. The officiant arrives.
9. The groom and best man enter, take their places at the right side of the head of the aisle, facing the congregation. The groom stands closest to the center, with the best man standing on his left slightly behind him.
10. The groomsmen lead the procession, walking two by two, with shortest men first and any junior groomsmen following the adults. The bridesmaids enter next, walking in pairs or singly, followed by the honor attendant, then the flower girl and ring bearer.
11. Processional music selected for the bride's entrance begins.
12. The bride arrives—accompanied by her father, both of her parents, her mother, her children, another escort, or by herself—and walks down the aisle to join the officiant and the groom.
13. The ceremony is performed.
14. The recessional music begins.
15. The bride and groom turn and walk up the aisle, followed by their attendants.
16. The ushers return and escort the family members from the front pews.
17. The remaining guests exit, beginning from the front.
18. After the recessional, the bride, groom, their mothers, the honor attendant, and the bridesmaids enter the limousines or cars waiting for them outside the church; or they form a receiving line; or they wait out of sight as guests exit, in order to briefly pose for wedding-party portraits.

19. If the bride and groom are to be showered by well-wishers, rose petals or bottles of bubbles that earlier had been distributed to the guests are used to "shower" the couple while they exit the ceremony site.
20. If additional photography is to be taken, the wedding party waits to the side as guests exit, then re-enters the building to have pictures taken as quickly as possible.
21. The bride and groom sign their papers, witnessed by the honor attendant and best man, before starting for the reception.
22. The wedding party departs for the reception (cars should be waiting in front of the ceremony site).

A Sample Wedding Reception Schedule

Amid all the excitement of the reception, the last thing you or the couple wants to worry about is whether everything is on schedule. The solution: Draw up a detailed timeline in advance, after consulting with the site manager, caterer, and wedding consultant—then make sure each of them (plus the photographer, videographer, and band leader or DJ) receives a copy well ahead of time.

Every wedding is unique, of course, but as a starting point, here's the schedule that one mother drew up for her daughter's recent summer wedding:

Pre-reception Schedule

Midafternoon	Flowers set up at reception site; any place cards for guests are arranged
5:00 PM	Ceremony at local house of worship
5:00 PM	At the reception site: employee meals, waitstaff meeting, and final preparations for cocktail hour
6:00–6:20 PM	Photos of bride and groom, their parents and immediate families, and attendants (note: the photo shoot is to be brief)
6:00–6:45 PM	Guests and the wedding party travel from ceremony to reception site

Reception Schedule

	
6:45–7:00 PM	Receiving line participants assemble
6:45 PM	Cocktail service started: served as first guests arrive; pass hors d'oeuvres, white wine, champagne, and sparkling water; bars are ready
7:00 PM	Dinner preparations finalized: bread, butter and water glasses are pre-set on tables (in ballroom)
7:00 PM	Cocktail hour; receiving line
7:30 PM	Salads pre-set on tables (in ballroom)
8:00 PM	Guests are invited into the ballroom and offered wine and champagne, sparkling water
8:10 PM	First course is served
8:30 PM	When all guests are seated and before first course is cleared, the bride and groom have their first dance, and the parents also dance
8:45 PM	First dances end during clearing of the first course
9:00 PM	Champagne is poured and entrée is served
9:10 PM	During entrée, best man makes a toast, followed by both fathers
10:00 PM	Cake is brought out and cake-cutting ceremony is held before clearing of entrée; cake is served with coffee/decaf
10:00 PM–Midnight	Dancing
11:30 PM	Bride leaves reception to change clothes, then throws her bouquet
Midnight	Bride and groom leave; reception ends

As you can see, this couple really wanted to have a party after dinner. They didn't want guests to be seated at their tables, still eating dinner at 10:00 PM. Their goals were to have a relatively short cocktail period and to have the first course on the tables when the guests entered the ballroom. They also wanted the first dances and the cake-cutting to take place while guests were seated at the tables, so these didn't intrude on dancing time. Their particular schedule enabled this bride and groom to have the reception of their dreams.

A Mom's Primer on Handling "Worst-Case Scenarios"

A savvy mom will have a plan in place to handle those unexpected — and potentially disastrous — situations that occasionally crop up. Here's what to do if...

- **An outdoor wedding is forced indoors by inclement weather.** If it looks like the planned outdoor ceremony will be rained out, have a "contingency team" at the ready to call each vendor with the news that the wedding venue has been changed. If it appears that rain is likely, you may even want to hold a quick rehearsal at your indoor location during the wedding rehearsal.

- **The officiant can't make the ceremony.** Ask the officiant to suggest a backup in advance. Any local clergyman or justice of the peace should have a substitute on call who can fill in at the last moment. If the officiant lives out of town, contact one or two local clergy ahead of time and ask if they can stand by as backups, just in case.

- **A guest lingers too long on the receiving line.** It's bad manners to tie up the receiving line by getting too chatty. If a guest's conversation extends beyond a quick greeting and expression of warm wishes, a parent of the bride or the groom should gently break in and say, "We're so glad you're here — let me introduce you to ..." and guide the guest to someone farther down the line.

- **Someone spills red wine on the bridal gown (or on your own dress) during the reception.** Soak any fresh wine stain *immediately* in club soda for several minutes, then rub gently and rinse. The stain should vanish. The next day, if there is any faint stain remaining, apply a nonbleach spot remover to the stained area and allow to set, then wash the gown by hand in cold water using a light detergent, and hang to drip dry.

- **An inebriated guest makes a toast and won't give up the microphone.** Prearrange a signal with the band or DJ to cue them to cut the microphone or to step in and tastefully take over. Or the DJ or band can start playing music (when they get the signal) to drown out the toaster.

The following, copy-ready pages can be used to record all pertinent information about your son or daughter's wedding—including a complete list of invited guests, gifts received, expenses, and contact information for vendors and key wedding participants.

WEDDING GUEST LIST

(Copy as many times as needed.)

Full name(s)_____

Address _____

Phone _____ E-mail _____ No. of people _____

RSVP/attending? yes ○ no ○ out of town (send map, info) yes ○ no ○

Full name(s)_____

Address _____

Phone _____ E-mail _____ No. of people _____

RSVP/attending? yes ○ no ○ out of town (send map, info) yes ○ no ○

Full name(s)_____

Address _____

Phone _____ E-mail _____ No. of people _____

RSVP/attending? yes ○ no ○ out of town (send map, info) yes ○ no ○

Full name(s)_____

Address _____

Phone _____ E-mail _____ No. of people _____

RSVP/attending? yes ○ no ○ out of town (send map, info) yes ○ no ○

Full name(s)_____

Address _____

Phone _____ E-mail _____ No. of people _____

RSVP/attending? yes ○ no ○ out of town (send map, info) yes ○ no ○

Party Guest List 〰

(Copy as many times as needed; for addresses, see "Wedding Guest List" worksheet on page 119.)

Event_____ Date _____

Guest(s)_____ RSVP yes ○ no ○ No. attending_____

Guest(s)_____ RSVP yes ○ no ○ No. attending_____

Guest(s)_____ RSVP yes ○ no ○ No. attending_____

Guest(s)_____ RSVP yes ○ no ○ No. attending_____

Guest(s)_____ RSVP yes ○ no ○ No. attending_____

Guest(s)_____ RSVP yes ○ no ○ No. attending_____

Guest(s)_____ RSVP yes ○ no ○ No. attending_____

Guest(s)_____ RSVP yes ○ no ○ No. attending_____

Guest(s)_____ RSVP yes ○ no ○ No. attending_____

Guest(s)_____ RSVP yes ○ no ○ No. attending_____

Guest(s)_____ RSVP yes ○ no ○ No. attending_____

Guest(s)_____ RSVP yes ○ no ○ No. attending_____

Guest(s)_____ RSVP yes ○ no ○ No. attending_____

Guest(s)_____ RSVP yes ○ no ○ No. attending_____

Guest(s)_____ RSVP yes ○ no ○ No. attending_____

Guest(s)_____ RSVP yes ○ no ○ No. attending_____

Guest(s)_____ RSVP yes ○ no ○ No. attending_____

Guest(s)_____ RSVP yes ○ no ○ No. attending_____

Guest(s)_____ RSVP yes ○ no ○ No. attending_____

Guest(s)_____ RSVP yes ○ no ○ No. attending_____

Guest(s)_____ RSVP yes ○ no ○ No. attending_____

Guest(s)_____ RSVP yes ○ no ○ No. attending_____

Guest(s)_____ RSVP yes ○ no ○ No. attending_____

WEDDING GIFT RECORD

(Copy as many times as needed; for addresses, see "Wedding Guest List" worksheet on page 119.)

No.	Date Rec'd	Gift	Given by	Where Bought	Date Thank-You Sent

SHOWER GIFT RECORD ⚜

(Copy as many times as needed; for addresses, see "Wedding Guest List" worksheet on page 119.)

No.	Date of Shower	Gift	Given by	Where Bought	Date Thank-You Sent

COMPARISON CHART FOR INTERVIEWS
with Service Providers and Ceremony/Reception Sites

(Copy as many times as needed.)

Before each interview, prepare a list of numbered questions about what services can be expected, and at what cost—then write in the numbers and their responses below. (For sample questions, see the "Key Things to Know…" sections in individual chapters.)

Interview for_____

TOPIC/QUESTION #	CHOICE #1 NAME: PHONE:	CHOICE #2 NAME: PHONE:

WEDDING BUDGET WORKSHEETS ⌁
Master Wedding Budget (Bride's Family—Traditional)

ITEM	COST (ESTIMATED)	COST (ACTUAL)
Accommodations		
Bride		
Bride's family		
Bride's attendants		
SUBTOTAL		
Flowers (ceremony)		
Flowers (bride, attendants, and corsages)		
Gifts		
Bride's gifts for attendants		
Bride's gift for groom		
SUBTOTAL		
Invitations and other printing		
Music (ceremony)		
Photography/videography		
Engagement photographs		
Photographer		
Videographer		
SUBTOTAL		
Reception (see worksheet)		
Transportation		

Item	Cost (Estimated)	Cost (Actual)
Wedding attire		
Bridal gown and accessories		
Bride's mother's outfit		
Groom's wedding ring		
Beauty costs (hair, nails, makeup)		
SUBTOTAL		
After-wedding brunch		
Wedding consultant fee		
Miscellaneous		
Tips (if not included in above costs)		
Taxes (if not included in above costs)		
TOTAL		
Other expenses:		
GRAND TOTAL		

Master Wedding Budget (Groom's Family—Traditional)

Item	Cost (Estimated)	Cost (Actual)
Accommodations		
Groom		
Groom's family		
Groom's attendants		
SUBTOTAL		
Bride's wedding ring		
Flowers		
Groom's boutonniere		
Groomsmen's/ushers' boutonnieres		
Ring bearer's boutonniere		
SUBTOTAL		
Groom's attire		
Groom's mother's outfit		
Gifts		
Groom's gift for bride		
Groom's gifts to attendants		
SUBTOTAL		
Honeymoon costs		

Item	Cost (Estimated)	Cost (Actual)
Marriage blood test fees		
Marriage license		
Officiant's fee		
Rehearsal dinner		
TOTAL		
Other expenses:		
GRAND TOTAL		

Reception Cost Breakdown ⌀⫶

Location rental	
Caterer: food	
adults @ $ =	
children @ $ –	
SUBTOTAL	
Caterer: beverages	
Wedding cake	
Waiters and bartenders	
Linens, place settings, and crystal	
Tables and chair rental	
Other equipment rentals	
Music	
Flowers	
Nonflower decorations	
Valet parking	
Coat check	
TOTAL	

REHEARSAL DINNER COST BREAKDOWN

Location rental	
Caterer: food	
adults @ $ =	
children @ $ =	
SUBTOTAL	
Caterer: beverages	
Waiters and bartenders	
Linens and equipment rental	
Valet parking	
Coat check	
Other expenses	
TOTAL	

FLOWERS COST BREAKDOWN

Ceremony	
Bride's bouquet	
Bride's head garland	
Attendants' bouquets	
Attendants' head garlands	
Flower girl's basket and petals	
Flower girl's head garland	
Groom's boutonniere	
Groomsmen's/Ushers' boutonnieres	
Fathers' boutonnieres	
Corsages for female relatives	
Entranceway	
Altar or *chuppah*	
Pews	
Candles	
Roses for parents	
Aisle runner	
Other	
SUBTOTAL	

Reception	
Table centerpieces	
Buffet tables	
Head table	
Place-card table	
Cake table	
Cake-topper, cake knife	
Mantels	
Stairways	
Entranceways	
Garnish for serving platters	
Restroom	
Other	
SUBTOTAL	
TOTAL	

INVITATIONS AND OTHER PRINTING COSTS BREAKDOWN

	QUANTITY	COST
Invitations		
Envelopes		
Wedding announcements		
Thank-you cards		
Response cards		
Other inserts		
Personal stationery		
Personalized favors		
Place cards		
Ceremony programs		
Calligraphy		
Postage		
TOTAL		

Music Cost Breakdown

Ceremony	
Organist	
Vocal soloist(s)	
Instrumental soloist(s)	
SUBTOTAL	
Reception	
Cocktail hour musicians	
Band or DJ	
Extras, special effects	
Meals	
Gratuities	
SUBTOTAL	
TOTAL	

PHOTOGRAPHY COST BREAKDOWN

Engagement photos	
Formal studio portrait	
Photographer's day rate	
Assistants' fees	
Wedding album	
Parents' albums	
Additional prints	
Color:	
4 X 6s @ $ =	
5 X 7s @ $ =	
8 X 10s @ $ =	
Black-and-white:	
4 X 6s @ $ =	
5 X 7s @ $ =	
8 X 10s @ $ =	
Negatives buyout	
Other	
Overtime charge	
Transportation	
Meal(s)	
TOTAL	

VIDEOGRAPHY COST BREAKDOWN ⌥

Videographer's fee	
Assistants' fees	
Video costs	
Full-length videos @ $ =	
Gift-length videos @ $ =	
Editing costs	
Other	
Overtime charge	
Transportation	
Meal(s)	
TOTAL	

TRANSPORTATION COST BREAKDOWN ⌥

Limousines for bridal party	
Traffic officials at ceremony, reception	
Travel costs for officiant	
TOTAL	

address book

Bride _____

Address _____

Phone (h)_____ Phone (w)_____

Phone (cell)_____ E-mail_____

Groom _____

Address _____

Phone (h)_____ Phone (w)_____

Phone (cell)_____ E-mail_____

Fiancé(e)'s parents_____

Address _____

Phone (h)_____ Phone (w)_____

Phone (cell)_____ E-mail_____

Accommodations #1_____ Contact person _____

Address _____

Phone_____ Fax _____

E-mail_____ Web site_____

Room rates_____

Accommodations #2 _____ Contact person _____

Address _____

Phone _____ Fax _____

E-mail _____ Web site _____

Room rates _____

ATTENDANTS

Honor attendant _____

Address _____

Phone (h) _____ Phone (w) _____

Phone (cell) _____ E-mail _____

Bridesmaid #1 _____

Address _____

Phone (h) _____ Phone (w) _____

Phone (cell) _____ E-mail _____

Bridesmaid #2 _____

Address _____

Phone (h) _____ Phone (w) _____

Phone (cell) _____ E-mail _____

Bridesmaid #3_____

Address _____

Phone (h)_____ Phone (w)_____

Phone (cell)_____ E-mail_____

Bridesmaid #4_____

Address _____

Phone (h)_____ Phone (w)_____

Phone (cell)_____ E-mail_____

Bridesmaid #5_____

Address _____

Phone (h)_____ Phone (w)_____

Phone (cell)_____ E-mail_____

Best man _____

Address _____

Phone (h)_____ Phone (w)_____

Phone (cell)_____ E-mail_____

Usher #1_____

Address _____

Phone (h)_____ Phone (w)_____

Phone (cell)_____ E-mail_____

Usher #2 _____

Address _____

Phone (h)_____ Phone (w)_____

Phone (cell)_____ E-mail_____

Usher #3 _____

Address _____

Phone (h)_____ Phone (w)_____

Phone (cell)_____ E-mail_____

Usher #4 _____

Address _____

Phone (h)_____ Phone (w)_____

Phone (cell)_____ E-mail_____

Usher #5 _____

Address _____

Phone (h)_____ Phone (w)_____

Phone (cell)_____ E-mail_____

Flower girl _____ Parents' names _____

Address _____

Phone (h)_____ Phone (w)_____

Phone (cell)_____ E-mail_____

Ring bearer _____ Parents' names _____

Address _____

Phone (h) _____ Phone (w) _____

Phone (cell) _____ E-mail _____

SITES, SERVICE PROVIDERS, AND VENDORS ⊛

Babysitter #1 _____

Address _____

Phone (h) _____ Phone (cell) _____

E-mail _____ Referred by _____

Babysitter #2 _____

Address _____

Phone (h) _____ Phone (cell) _____

E-mail _____ Referred by _____

Baker _____ Contact person _____

Address _____

Phone _____ Fax _____

E-mail _____ Web site _____

Bridal gown vendor_____ Contact person_____

Address_____

Phone_____ Fax _____

E-mail_____ Web site_____

Car/limousine service _____ Contact person_____

Address_____

Phone_____ Fax _____

E-mail_____ Web site_____

Rates_____

Caterer_____ Contact person_____

Address_____

Phone_____ Fax _____

E-mail_____ Web site_____

Ceremony location_____ Contact person_____

Address_____

Phone_____ Fax _____

E-mail_____ Web site_____

Florist _____ Contact person _____

Address _____

Phone _____ Fax _____

E-mail _____ Web site _____

Hairdresser _____ Contact person _____

Address _____

Phone _____ Fax _____

E-mail _____ Web site _____

Makeup artist _____ Contact person _____

Address _____

Phone _____ Fax _____

E-mail _____ Web site _____

Musical entertainment (reception) _____ Contact person _____

Address _____

Phone _____ Fax _____

E-mail _____ Web site _____

Musician #1 (ceremony) _____

Address _____

Phone _____ Fax _____

E-mail _____ Web site _____

Musician #2 (ceremony)_____

Address _____

Phone_____ Fax _____

E-mail_____ Web site _____

Officiant_____

Address _____

Phone_____ E-mail _____

Photographer_____ Contact person _____

Address _____

Phone_____ Fax _____

E-mail_____ Web site _____

Printer (ceremony program)_____ Contact person _____

Address _____

Phone_____ Fax _____

E-mail_____ Web site _____

Delivery date of program proofs _____ Delivery date of final program_____

Printer (invitations, stationery)_____ Contact person _____

Address _____

Phone_____ Fax _____

E-mail_____ Web site _____

Delivery date of invitation proofs _____ Delivery date of final invitations_____

Reception location_____ Contact person_____

Address_____

Phone_____ Fax _____

E-mail_____ Web site _____

Videographer_____ Contact person_____

Address_____

Phone_____ Fax _____

E-mail_____ Web site _____

Wedding consultant _____

Address_____

Phone_____ Fax _____

E-mail_____ Web site _____

GIFT REGISTRIES

Store registry #1_____ Contact person_____

Address_____

Phone_____ Fax _____

E-mail_____ Web site _____

Store registry #2_____ Contact person _____

Address _____

Phone_____ Fax _____

E-mail_____ Web site _____

Store registry #3_____ Contact person _____

Address _____

Phone_____ Fax _____

E-mail_____ Web site _____

WEDDING-RELATED PARTIES ⟨∰⟩

Rehearsal dinner location_____

Contact person _____ Host _____

Address _____

Phone_____ Fax _____

E-mail_____ Web site _____

Wedding shower #1_____ Host _____

Address _____

Phone (h)_____ Phone (w)_____

Phone (cell)_____ E-mail_____

Wedding shower #2 _____ Host _____

Address _____

Phone (h) _____ Phone (w) _____

Phone (cell) _____ E-mail _____

Party #1 _____ Host _____

Address _____

Phone (h) _____ Phone (w) _____

Phone (cell) _____ E-mail _____

Party #2 _____ Host _____

Address _____

Phone (h) _____ Phone (w) _____

Phone (cell) _____ E-mail _____

Party #3 _____ Host _____

Address _____

Phone (h) _____ Phone (w) _____

Phone (cell) _____ E-mail _____

Party #4 _____ Host _____

Address _____

Phone (h) _____ Phone (w) _____

Phone (cell) _____ E-mail _____

EMILY POST

JAMES MONTGOMERY FLAGG

EMILY POST 1872 TO 1960

Emily Post began her career as a writer at the age of thirty-one. Her romantic stories of European and American society were serialized in *Vanity Fair*, *Collier's*, *McCall's*, and other popular magazines. Many were also successfully published in book form.

On its publication in 1922, her book, *Etiquette*, topped the nonfiction bestseller list and the phrase "according to Emily Post" soon entered our language as the last word on the subject of social conduct. Mrs. Post, who as a girl had been told that well-bred women should not work, was suddenly a pioneering American woman. Her numerous books, a syndicated newspaper column, and a regular network radio program made Emily Post a figure of national stature and importance throughout the rest of her life.

Good manners reflect something from inside~
an innate sense of consideration for others
and respect for self.

—Emily Post

also available *Emily Post's*

WEDDING ETIQUETTE

ISBN 0-06-074504-5 (hardcover)
Fifth Edition

*T*oday's weddings are more complicated than ever, with new traditions replacing old, and new relationships to consider as family life grows more complex. In this new edition, Peggy Post provides enlightened solutions to all your wedding questions.

WEDDING PLANNER

ISBN 0-06-074503-7 (hardcover)
Fourth Edition

*I*t's time to plan your wedding! Peggy Post is ready to help you—in this new edition of *Emily Post's Wedding Planner*. Combining appealing design with streamlined practicality, this book helps you organize the wedding of your dreams, from the beginning of your engagement until you start your new married life.

www.emilypost.com